ArtNotes

A Lecture and Study Companion to Accompany

Art History
VOLUME ONE
REVISED SECOND EDITION

Marilyn Stokstad

PEARSON
Prentice
Hall

Upper Saddle River, New Jersey 07458

© 2005 by PEARSON EDUCATION, INC.
Upper Saddle River, New Jersey 07458

ISBN 0-13-146607-0

Printed in the United States of America

Museum credits for fine art photos can be found with the images in the text. Please consult your textbook if you are studying the objects for identification purposes.

CONTENTS

BEFORE YOU BEGIN

The field of art history involves the study of two kinds of information: *visual* information and *historical* information. You will want to keep track of both, learning about the key events of a particular period as well as the specifics of the particular works of art that were produced in each period.

ArtNotes was created to help you with the unique challenges of integrating the two. Designed as a notebook, with captions and examples of fine art, diagrams and maps, *ArtNotes* also includes space for taking down important points as you read or listen to lectures. Section headings and boxed features help to guide you through the material, providing a rough outline to help keep track of information, both in class and on your own.

Most art history classes include slide presentations to help develop *visual literacy*. Visual literacy is the ability to "read" a work of art, noting its elements, style, and organization. During the lectures, you will want to note information about particular works of art as they are discussed, sometimes in comparison with other artworks. *ArtNotes* provides captions and diagrams as well as certain works of art, so you can jot down the information as it is provided by the instructor. Then, because each caption includes the page number of your text, you can review the material when you are studying, and fill in additional notes as you read.

Art history lectures will also include *historical* information. This provides the context in which a particular work of art was created. Key philosophical movements, major political events, wars, and discoveries all play a part both in a work's *content*—what the piece is about and its *form*—how the piece is created. The maps, section headings, and brief quotations will help to orient you to the major themes of each period, and again, you can note these things as you listen in class, and then fill in the details as you read and study.

To get the most out of your art history experience, it is useful to read the assigned material on a topic or period, taking careful notes, before the lecture. Keep these points in mind as you read:

- In general, you should focus on: 1) historical context for an era; 2) characteristics of the main stylistic trends of an era, such as the characteristics of Impressionism; and 3) main artists and composers of the era and their most famous works.

- Zero in on the most important words, eliminating extraneous ones. Also, put the information in your own words, even using acronyms or other catchy ways to help you learn the material.

- Remember to look at the pictures, and *think about* what you are studying. The thumbnail photos in ArtNotes are useful for references, but they can't give you the same experience as engaging with the color plates in the textbook as you read about them. If your mind is engaged as you read the text and study the images, much of the content will make sense and stay with you.

If you have taken good notes on your text, much of the material covered in class should be familiar to you. Try to listen more and write less. In other words, absorb what the professor is saying, look at

or listen to the examples provided, and work towards *understanding* the material. Only jot down reminders of material you remember from the textbook and anything presented that expands on what was in the text.

Review your class notes with the notes from your reading the same day, filling in any gaps in the material from your text. The goal is to create a complete and helpful picture using both sources of information.

Have fun! This course is designed to put you in touch with many of the world's greatest works and ideas. You will better master the material if you are willing to relax and have a good time with it.

INTRODUCTION

Notes

1. The Great Sphinx, Giza, Egypt. Dynasty 4, c. 2613-2494 BCE *(page xxv)*

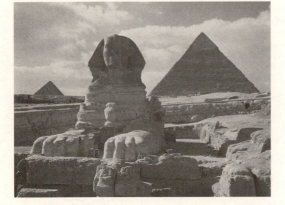

WHAT IS ART?

2. Corinthian capital from the *tholos* at Epidaurus, c. 350 BCE. *(page xxvi)*

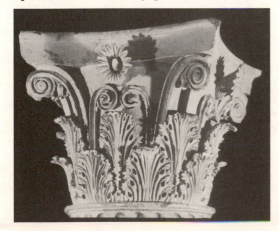

3. Adriaen van der Spelt and Frans van Mieris.
Flower Piece with Curtain. 1658. *(page xxvii)*

NATURE OR ART?

STYLES OF REPRESENTATION

4. Edward Weston. *Succulent.* 1930. *(page xxviii)*

5. Georgia O'Keeffe. *Red Canna.* 1924. *(page xxviii)*

6. David Smith. *Cubi XIX.* 1964. *(page xxix)*

THE HUMAN BODY AS IDEA AND IDEAL

7. Medici Venus. Roman copy of a 1st century BCE.
(page xxx)

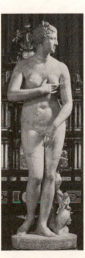

8. Charles V. Triumphing over Fury. *(page xxix)*

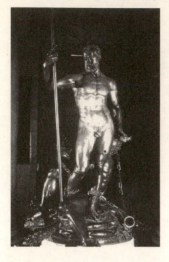

9. Kitagawa Utamaro. *Woman at the Height of Her Beauty.* Mid-1790s. *(page xxxi)*

10. Punitavati (Karaikkalammaiyar), Shiva saint, from Karaikka, India. c. 1050. *(page xxxii)*

WHY DO WE NEED ART?

ART AND THE SEARCH FOR MEANING

11. James Hampton. *Throne of the Third Heaven of the Nations' Millennium General Assembly.* c. 1950-64. *(page xxxii)*

12. Chalice of Abbot Suger, from Abbey Church of Saint-Denis, France. *(page xxxiii)*

13. Olowe of Ise. Offering bowl, Nigeria,
c. 1925. *(page xxxiii)*

ART AND THE SOCIAL CONTEXT

14. Veronese. *The Triumph of Venice,* oil on
canvas in the Council Chamber, Palazzo Ducale,
Venice, Italy. c. 1585. *(page xxxiv)*

WHO ARE ARTISTS?

15. Il Guercino. *Saint Luke Displaying a Painting of the Virgin.* 1652-53. *(page xxxv)*

16. Dale Chihuly. *Violet Persian Set with Red Lip Wraps.* 1990. *(page xxxvi)*

WHO ARE ARTISTS?

17. Jan Steen. *The Drawing Lesson.* 1665. *(page xxxvi)*

18. Leonardo. *The Last Supper,* wall painting in the refectory, Monastery of Santa Maria delle Grazie, Milan, Italy 1495-98. *(page xxxvi)*

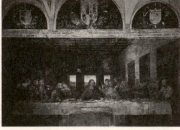

19. Rembrandt van Rijn. *The Last Supper,* after Leonardo da Vinci's fresco. Mid-1630s. *(page xxxvii)*

WHAT IS A PATRON?

INDIVIDUAL PATRONS

20. Christine de Pizan Presenting Her Book to the Queen of France. 1410-15. *(page xxxviii)*

21. James McNeill Whistler. *Harmony in Blue and Gold.* The Peacock Room, northeast corner, from a house owned by Frederick Leyland, London. 1876-77. *(page xxxviii)*

INSTITUTIONAL PATRONAGE: MUSEUMS AND CIVIC BODIES

22. Frank Lloyd Wright. Solomon R. Guggenheim Museum, New York City. 1956-59. *(page xxxix)*

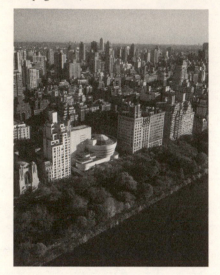

23. Lawrence Alma-Tadema. *Pheidias and the Frieze of the Parthenon, Athens.* 1868. *(page xxxix)*

WHAT IS ART HISTORY?

STUDYING ART FORMALLY AND CONTEXTUALLY

DEFENDING ENDANGERED OBJECTS

24. Hagesandros, Polydoros, and Athanadoros of Rhodes. Laocoön and His Sons, as restored today. Probably the original of 1st century CE or a Roman copy of the 1st century CE. *(page xl)*

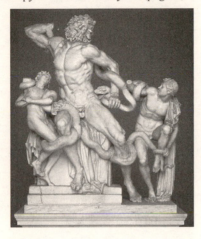

25. Hagesandros, Polydoros, and Athanadoros of Rhodes. *Laocoön and His Sons*, in an earlier restoration. *(page xli)*

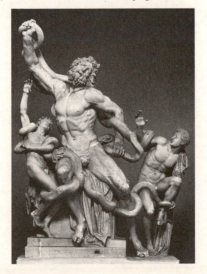

UNCOVERING SOCIOPOLITICAL INTENTIONS

26. Honoré Daumier. *Rue Transonain, Le 15 Avril 1834.* *(page xli)*

27. Roger Shimomura. *Diary* **(Minidoka Series #3).** 1978. *(page xlii)*

WHAT IS THE VIEWER'S RESPONSIBILITY?

The Object Speaks:
Large Plane Trees

28. Vincent van Gogh. Large Plane Trees 1889.
(page xliii)

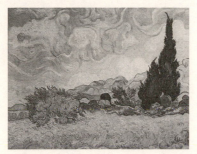

1

PREHISTORY AND PREHISTORIC ART IN EUROPE

1-1. Wall painting with horses, rhinoceroses, and aurochs, Chauvet cave, Vallon-Pont-d'Arc, Ardèche gorge, France. c. 25,000–17,000 BCE. *(page 1)*

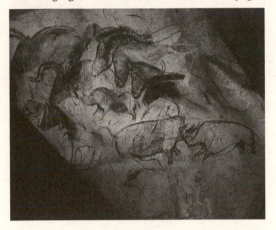

THE PALEOLITHIC PERIOD

Map 1-1. Prehistoric Europe. As the Ice Age glaciers receded, Paleolithic, Neolithic, Bronze Age, and Iron Age settlements increased from south to north. *(page 2)*

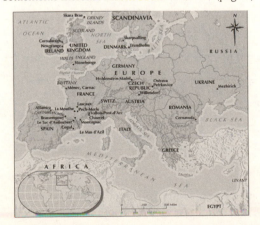

THE BEGINNING OF ARCHITECTURE

1-2. Reconstruction drawing of mammoth-bone house, from Ukraine. c. 16,000–10,000 BCE. *(page 3)*

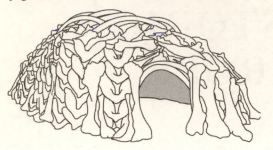

SCULPTURE

1-3. *Lion-Human*, from Hohlenstein-Stadel, Germany. c. 30,000–26,000 BCE. *(page 4)*

1-4. *Woman from Willendorf,* Austria.
c. 22,000–21,000 BCE. *(page 4)*

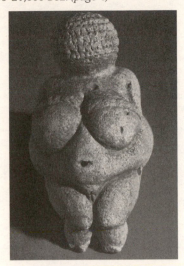

1-5. *Woman from Ostrava Petrkovice,* Czech
Republic. c. 23,000 BCE. *(page 5)*

1-6. *Woman from Brassempouy,* Grotte du Pape,
Brassempouy, Landes, France. c. 22,000 BCE. *(page 5)*

Notes

17

CAVE ART

1-7. *Spotted Horses and Human Hands*,
Pech-Merle cave, Dordogne, France. Horses c.
16,000 BCE; hands c. 15,000 BCE. *(page 6)*

Technique: Prehistoric Wall Painting

1-8. *Bison,* on the ceiling of a cave at Altamira, Spain. c. 12,000 BCE. *(page 8)*

1-9. Plan of Lascaux caves, Dordogne, France. *(page 8)*

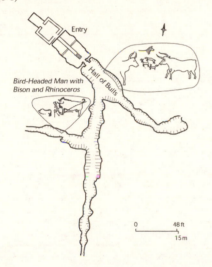

1-10. Hall of Bulls, Lascaux caves, Dordogne, France, c. 15,000–13,000 BCE. *(page 9)*

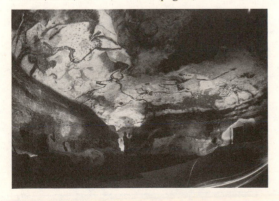

1-11. *Bird-Headed Man with Bison and Rhinoceros,*
Lascaux caves. c. 15,000–13,000 BCE. *(page 9)*

1-12. *Bison,* Le Tuc d'Audoubert, France. c. 13,000 BCE.
(page 11)

1-13. **Lamp with ibex design,** from La Mouthe cave,
Dordogne, France. c. 15,000–13,000 BCE. *(page 11)*

THE NEOLITHIC PERIOD

ROCK-SHELTER ART

1-14. *People and Animals,* detail of rock-shelter painting, Cogul, Lérida, Spain. c. 4000–2000 BCE. *(page 13)*

ARCHITECTURE

Elements of Architecture:
Post-and-Lintel and Corbel Construction

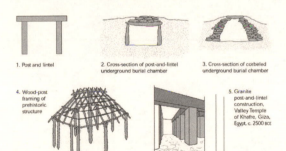

1. Post and lintel

2. Cross-section of post-and-lintel underground burial chamber

3. Cross-section of corbeled underground burial chamber

4. Wood-post framing of prehistoric structure

5. Granite post-and-lintel construction, Valley Temple of Khafre, Giza, Egypt. c. 2500 BCE

1-15. Plan, village of Skara Brae, Orkney
Islands, Scotland. c. 3100–2600 BCE. *(page 15)*

1-16. House interior, Skara Brae (house 7 in
fig. 1-17). *(page 15)*

**1-17. Tomb interior with corbeling and engraved
stones,** Newgrange, Ireland. c. 3000–2500 BCE *(page 16)*

1-18. Menhir alignments at Ménec, Carnac, France. c. 4250–3750 BCE. *(page 17)*

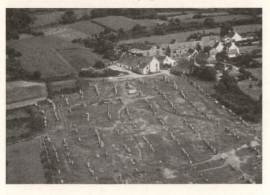

1-19. Stonehenge, Salisbury Plain, Wiltshere England. c. 2750–1500 BCE. *(page 18)*

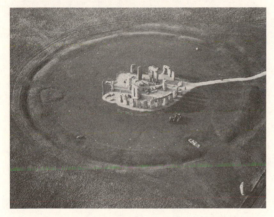

1-20. Diagram of Stonehenge. *(page 18)*

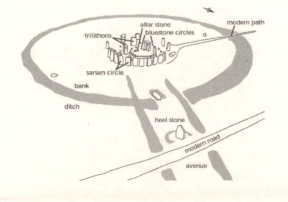

1-21. Within Circle, Looking Toward Heel Stone, Stonehenge England. *(page 19)*

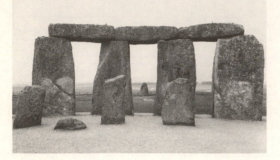

SCULPTURE AND CERAMICS

1-22. Menhir statue of a woman, from Montagnac, France. c. 2000 BCE. *(page 20)*

The Object Speaks:
Prehistoric Woman and Man

1-23. Figures of a woman and a man, from
Cernavoda, Romania. c. 3500 BCE. *(page 21)*

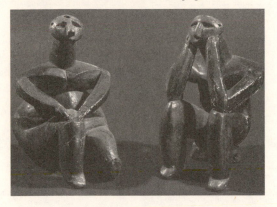

1-24. Vessels, from Denmark. c. 3000–2000 BCE.
(page 22)

THE BRONZE AGE

1-25. *Horse and Sun Chariot* **and schematic drawing of incised design,** from Trundholm, Denmark. c. 1800–1600 BCE. *(page 23)*

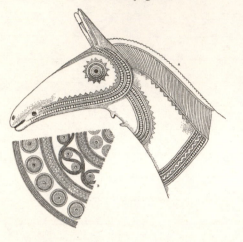

THE IRON AGE

1-26. Openwork box lid, from Cornalaragh County Conaghan, Ireland. La Tène period, c. 1st century BCE. *(page 24)*

2

ART OF THE ANCIENT NEAR EAST

Notes

2-1. ***Human-Headed Winged Lion (Lamassu),*** gateway support from the palace of Assurnasirpal II, Mesapotamia, Assyria, Nimrud. 883–859 BCE. *(page 26)*

THE FERTILE CRESCENT

Map 2-1. The Ancient Near East. Ancient Mesopotamia (modern Iraq) was the Fertile Crescent between the Tigris and Euphrates rivers. *(page 28)*

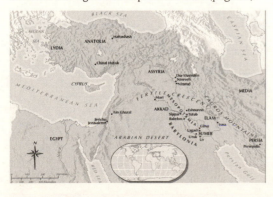

EARLY NEOLITHIC CITIES

2-2. Reconstruction drawing of houses at Ain Ghazal, Jordan. c. 7200–5000 BCE. *(page 29)*

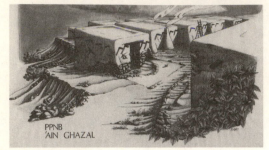

2-3. Figure, from Ain Ghazal, Jordan. c. 7000–6000 BCE. *(page 29)*

2-4. Composite reconstruction drawing of a shrine room at Chatal Huyuk, Anatolia (modern Turkey). c. 6500–5500 BCE. *(page 30)*

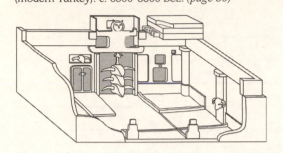

2-5. Reconstruction drawing of the Anu Ziggurat and White Temple, Uruk (modern Warka, Iraq). c. 3100 BCE. *(page 30)*

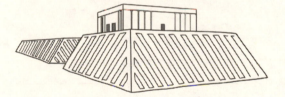

SUMER

Cuneiform Writing

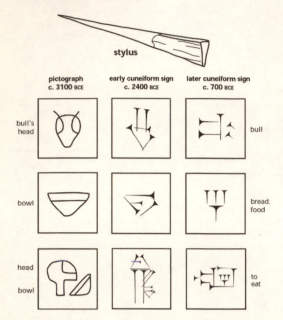

Gilgamesh

The so-called *Flood Tablet, Tablet XI, The Epic of Gilgamesh,* 2nd millennium BCE. The British Museum, London. *(page 31)*

2-6. Illustration of the technique of cone mosaic. *(page 32)*

2-7. Nanna Ziggurat, Ur (modern Muqaiyir, Iraq). c. 2100–2050 BCE. *(page 32)*

2-8. Face of a woman, from Uruk (modern Warka, Iraq). c. 3300–3000 BCE. *(page 33)*

2-9. Carved vase (both sides), called the Uruk Vase, from Uruk (modern Warka, Iraq). c. 3300–3000 BCE. *(page 33)*

2-10. Votive statues, from the Square Temple, Eshnunna (modern Tell Asmor, Iraq). c. 2900–2600 BCE. *(page 34)*

2-11. Scarlet Ware vase, from Tutub (modern Tell Khafajeh, Iraq). c. 3000–2350 BCE. *(page 34)*

2-12. Great Lyre with bull's head, from the tomb
of King Meskalamdug, Ur (modern Muqaiyir, Iraq).
c. 2550–2400 BCE. *(page 35)*

2-13. Mythological figures, detail of the
sound box of the Great Lyre from Ur. *(page 35)*

**2-14. Cylinder seal from Sumer and its
impression.** c. 2500 BCE. *(page 36)*

AKKAD

2-15. *Disk of Enheduanna,* from Ur (modern
Muqaiyir, Iraq). c. 2300–2184 BCE. *(page 37)*

2-16. *Stele of Naramsin.* c. 2254–2218 BCE.
(page 37)

AKKAD

LAGASH

2-17. Votive statue of Gudea, from Lagash
(modern Telloh, Iraq). c. 2120 BCE. *(page 38)*

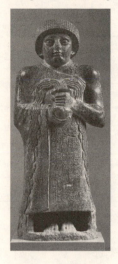

BABYLON AND MARI

**The Object Speaks:
The Code of Hammurabi**

2-18. *Stele of Hammurabi,* from Susa (modern
Shush, Iran). c. 1792–1750 BCE. *(page 39)*

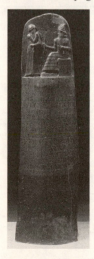

2-19. *Investiture of Zimrilim (Zimiri-Lim, King of Mari, before the Goddess Ishtar),* facsimile of a wall painting on mud plaster from the Zimrilim palace at Mari (modern Tell Hariri, Iraq), Court 106. Before c. 1750 BCE. *(page 40)*

ASSYRIA

2-20. *Assurnasirpal II Killing Lions,* from the palace complex of Assurnasirpal II, Kalhy Nimrud, Iraq (modern). c. 850 BCE. *(page 41)*

2-21. Reconstruction drawing of the citadel and palace complex of Sargon II, Dur Sharrukin (modern Khorsabad, Iraq). c. 721–706 BCE. *(page 41)*

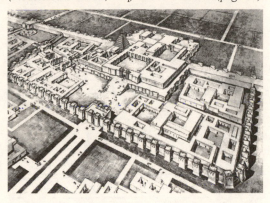

2-22. *Assurbanipal and His Queen in the Garden,* from the palace at Nineveh (modern Kuyunjik, Iraq). c. 647 BCE. *(page 42)*

2-23. Earrings, crown, and rosettes, from the tomb of Queen Yabay, KalhuNimrud, Iraq (modern). Late 8th century BCE. *(page 42)*

NEO-BABYLONIA

2-24. Reconstruction drawing of Babylon in the 6th century BCE. *(page 43)*

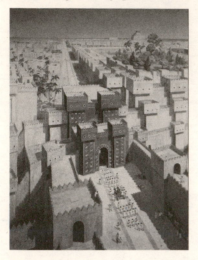

2-25. Ishtar Gate and throne room wall (modified for installation), from Babylon (modern Iraq) c. 575 BCE. *(page 44)*

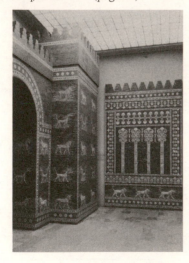

ELAM

2-26. Beaker, from Susa (modern Shush, Iran). c. 4000 BCE. *(page 45)*

ANATOLIA

2-27. *Woman Spinning,* from Susa (modern Shush, Iran). c. 8th–7th century BCE. *(page 47)*

2-28. Lion Gate, Hattushash (near modern Boghazkeui, Turkey). c. 1400 BCE. *(page 47)*

PERSIA

2-29. Plan of the ceremonial complex, Persepolis, Iran. 518–c. 460 BCE. *(page 48)*

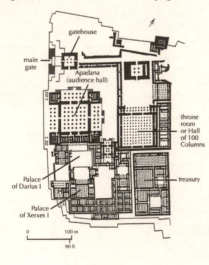

**2-30. Apadana (audience hall) of Darius
and Xerxes,** ceremonial complex, Persepolis,
Iran. 518–c. 460 BCE. *(page 49)*

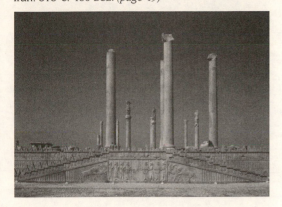

2-31. *Darius and Xerxes Receiving Tribute,*
detail of a relief from the stairway leading to the
Apadana, ceremonial complex, Persepolis, Iran. 491–486 BCE.
(page 50)

Technique: Coining Money

Front and back of a gold coin first minted under
Croesus, king of Lydia. 560–546 BCE. *(page 50)*

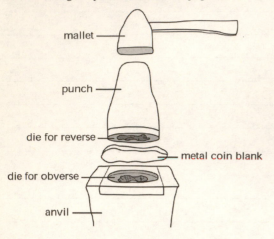

- mallet
- punch
- die for reverse
- metal coin blank
- die for obverse
- anvil

2-32. Daric, a coin first minted under Darius I of
Persia. 4th century BCE. *(page 51)*

3

ART OF ANCIENT EGYPT

Notes

3-1. Funerary mask of Tutankhamun.
Dynasty 18, c. 1327 BCE. *(page 53)*

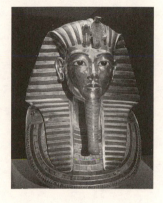

NEOLITHIC AND PREDYNASTIC EGYPT

Map 3-1. Ancient Egypt. Upper (southern)
Egypt and Lower (northern) Egypt were united
about 3100 BCE. *(page 54)*

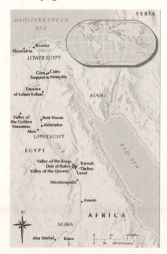

3-2. Jar with boat designs, from Hierakonpolis.
Predynastic, c. 3500–3400 BCE. *(page 55)*

EARLY DYNASTIC EGYPT

RELIGIOUS BELIEFS

Egyptian Symbols

White Crown
of Upper Egypt

Red Crown
of Lower Egypt

Double Crown
of unified Egypt

sun disk
cobra
scepter
ankh

wedjat
(eye of Horus)

falcon
(the god Horus)

Horus

ankh

scarab

THE PALETTE OF NARMER

3-3. ***Palette of Narmer,*** from Hierakonpolis.
Dynasty 1, c. 3000 BCE. *(page 57)*

REPRESENTATION
OF THE HUMAN FIGURE

3-4. ***Sculptors at Work,*** relief from Saqqara.
Dynasty 5, c. 2150–2460 BCE. *(page 58)*

3-5. An Egyptian canon of proportions for representing the human body. *(page 59)*

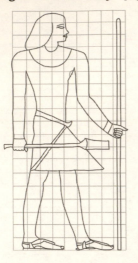

THE OLD KINGDOM

FUNERARY ARCHITECTURE

3-6. Plan of Djoser's funerary complex, Saqqara. Dynasty 3, c. 2667–2648 BCE. *(page 60)*

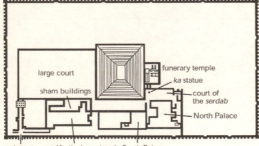

3-7. Stepped pyramid and sham buildings of funerary complex of Djoser, Saqqara. *(page 61)*

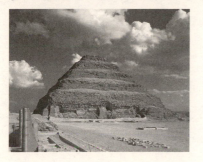

3-8. Wall of the North Palace, with engaged columns in the form of papyrus blossoms, funerary complex of Djoser, Saqqara. *(page 61)*

Elements of Architecture:
Mastaba to Pyramid

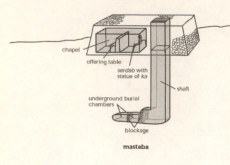

chapel

offering table

serdab with
statue of *ka*

shaft

underground burial
chambers

blockage

mastaba

3-9. Great Pyramids, Giza. Dynasty 4,
c. 2601–2515 BCE. *(page 63)*

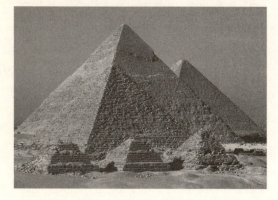

3-10. Model of the Giza plateau, showing from left to right the temples and pyramids of Menkaura, Khafra, and Khufu. (Number 4 is the valley temple of Menkaura; number 5 is the valley temple and Sphinx of Khafra. *(page 61)*

Elements of Architecture:
Column

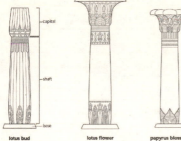

lotus bud lotus flower papyrus blossom palm leaf

SCULPTURE

3-11. *Khafra,* from Giza Valley, Temple of Kjafra. Dynasty 4, c. 2500 BCE. *(page 65)*

3-12. *Menkaura and a Queen,* perhaps his wife Khamerernebty, from Giza. Dynasty 4, c. 2500 BCE. *(page 65)*

3-13. *Pepy II and His Mother, Queen Merye-ankhnes.* Dynasty 6, c. 2288–2224 2194 BCE. *(page 66)*

3-14. *Seated Scribe,* from the tomb of Kai, Saqqara. Dynasty 5, c. 2494–2345 BCE. *(page 66)*

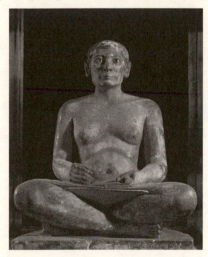

TOMB DECORATION

3-15. *Ti Watching a Hippopotamus Hunt,* from the tomb of Ti, Saqqara. Dynasty 5, c. 2510–2460 BCE. *(page 67)*

Technique:
Egyptian Painting and Relief Sculpture

THE MIDDLE KINGDOM

ARCHITECTURE AND TOWN PLANNING

3-16. Plan of the northern section of Kahun, built during the reign of Senusret II near modern el-Lahun. Dynasty 12, c. 1880–1874 BCE. *(page 69)*

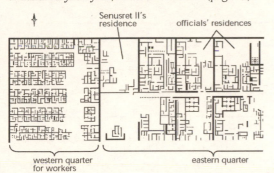

Senusret II's residence

officials' residences

western quarter for workers

eastern quarter

TOMB ART AND TOMB CONSTRUCTION

3-17. Model of a house and garden, from tomb of Meketra, Thebes. Dynasty 11, c. 2125–2055 BCE. *(page 69)*

3-18. Rock-cut tombs, Beni Hasan. Dynasty
12, c. 1985–1795 BCE. *(page 70)*

**3-19. Interior of rock-cut tomb of Khnumhotep,
Beni Hasan.** Dynasty 12, c. 1985–1795 BCE. *(page 70)*

3-20. Funerary Stele of Amenemhat I, from
Assasif. Dynasty 11, 2055–1985 BCE. *(page 70)*

SCULPTURE

3-21. Head of Senusret III. Dynasty 12,
1836–1855 BCE. *(page 71)*

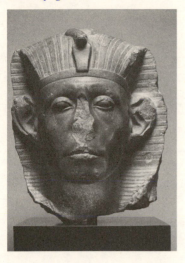

Hieroglyphic, Hieratic,
and Demotic Writing

The Rosetta Stone with its three tiers of writing,
from top to bottom: hieroglyphic, demotic, and
Greek. 196 BCE. *(page 72)*

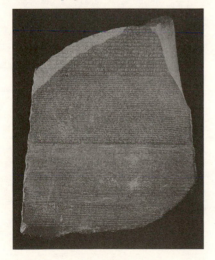

Hieroglyphic signs for the letters P, T, O, and L,
which were Champollion's clues to deciphering the
Rosetta Stone, plus M, Y, and S: Ptolmys. *(page 72)*

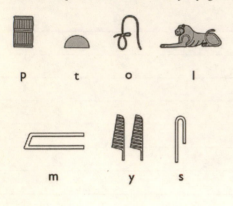

p t o l

m y s

SMALL OBJECTS FOUND
IN TOMBS

3-22. Hippopotamus, from the tomb of Senbi
(Tomb B.3), Meir. Dynasty 12, c. 1985–1795 BCE. *(page 73)*

3-23. Pectoral of Senusret II, from the tomb
of Princess Sithathoryunet, el-Lahun. Dynasty 12,
c. 1895–1878 BCE. *(page 73)*

THE NEW KINGDOM

GREAT TEMPLE COMPLEXES

3-24. Map of the Thebes district. *(page 74)*

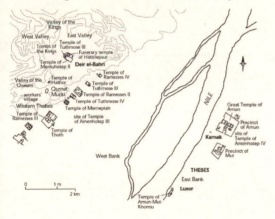

3-25. The ruins of the Great Temple of Amon at Luxor at Karnak, Egypt. *(page 74)*

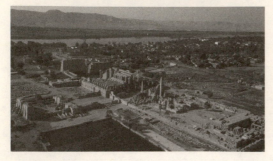

3-26. Plan of the Great Temple of Amun, Karnak. New Kingdom, c. 1295–1186 BCE. *(page 75)*

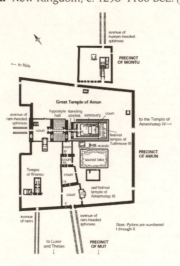

3-27. Reconstruction drawing of the hypostyle hall, Great Temple of Amun, Kamar. Dynasty 19, c. 1295–1186 BCE *(page 75)*

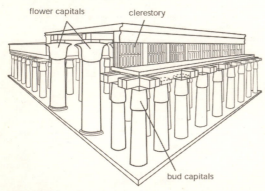

3-28. Flower and bud columns, hypostyle hall, Great Temple of Amun, Karnak *(page 75)*

3-29. Pylon of Rameses II with obelisk in the foreground, Temple of Amun, Mut, and Khons, Luxor. Dynasty 19, c. 1279–1213 BCE. *(page 76)*

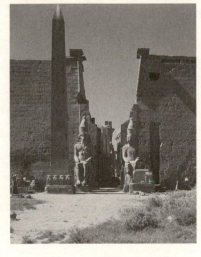

3-30. *Hatshepsut as Sphinx*, from Deir el-Bahri. Dynasty 18, c. 1473–1458 BCE. *(page 76)*

3-31. Funerary temple of Hatshepsut, Deir el-Bahri. Dynasty 18, c. 1473–1458 BCE. *(page 77)*

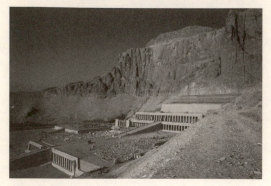

3-32. Plan of the funerary temple of Hatshepsut, Deir el-Bahri. *(page 77)*

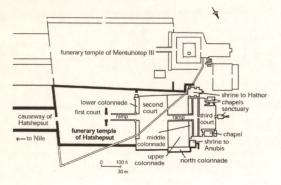

AKHENATEN AND THE ART OF THE AMARNA PERIOD

3-33. *Akhenaten and His Family,* from Akhetaten (modern Tell el-Amarna). Dynasty 18, c. 1348–1336 BCE. *(page 78)*

3-34. *Queen Tiy,* from Kom Medinet el-Ghurab (near el-Lahun). Dynasty 18, c. 1352 BCE. *(page 79)*

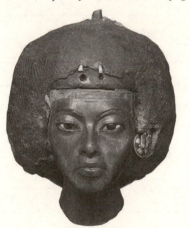

3-35. *Nefertiti,* from Akhetaten (modern Tell el-Amarna). Dynasty 18, c. 1348–1336 BCE. *(page 79)*

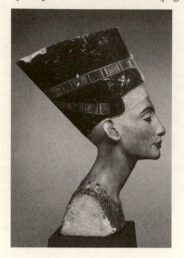

3-36. Fish-shaped vase, from Akhetaten (modern Tell el-Amarna). Dynasty 18, c. 1348–1336 BCE. *(page 79)*

3-37. Hand mirror. Dynasty 18, c. 1478–1390 BCE. *(page 80)*

THE RETURN TO TRADITION

3-38. Funerary mask Tutankhamun, from the tomb of Tutankhamun, Valley of the Kings, Deir el-Bahri. (Dynasty 18, c. 1336–1327 BCE). *(page 81)*

3-39. Inner coffin of Tutankhamun's sarcophagus, from the tomb of Tutankhamun, Valley of the Kings, near Deir el-Bahri. Dynasty 18, c. 1336–1327 BCE. *(page 81)*

3-40. Temples of Rameses II (left) **and Nefertari** (right)**, Abu Simbel.** Dynasty 19, c. 1279–1213 BCE. *(page 82)*

3-41. Temple of Rameses II, Abu Simbel. Dynasty 19, c. 1279–1213 BCE. *(page 82)*

The Object Speaks:
The Temples of Rameses II

3-42. Colossal statue of Rameses II in his temple complex at Luxor, Egypt. Dynasty 19, c. 1279–1213 BCE. *(page 83)*

3-43. *Queen Nefertari Making an Offering to Isis*, wall painting in the tomb of Nefertari, Valley of the Queens, near Deir el-Bahri. Dynasty 19, c. 1279–1213 BCE. *(page 84)*

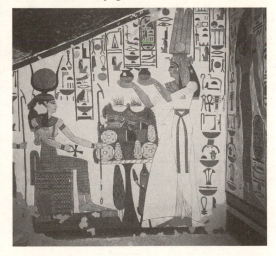

3-44. Garden of Nebamun (Pond in a Garden), wall painting from the tomb of Nebamun, Thebes. Dynasty 18, c. 1400–1350 BCE. *(page 84)*

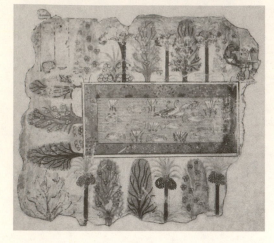

Restoring the Tomb of Nefertari

Getty Conservation Institute conservator S. Rickerby at work in Chamber K, tomb of Nefertari, Valley of the Queens, near Deir el-Bahri. *(page 85)*

BOOKS OF THE DEAD

3-45. *Judgment of Hunefer before Osiris,*
illustration from a Book of the Dead. Dynasty 19,
c. 1285 BCE. *(page 86)*

THE CONTINUING INFLUENCE
OF EGYPTIAN ART

3-46. Sphinx of Taharqo, from Temple T,
Kawa, Nubia. Dynasty 25, c. 690–664 BCE. *(page 87)*

3-47. Mummy wrapping of a young boy, from
Hawara. Roman period, c. 100–120 CE. *(page 87)*

AEGEAN ART

4-1. "Flotilla" fresco, from Room 5 of West House, Akrotiri, Thera, Second Palace period, c. 1650 BCE. *(page 88)*

THE AEGEAN WORLD

Map 4-1. The Aegean World. The three main cultures in the ancient Aegean were the Cycladic, in the Cyclades; the Minoan, on Thera and Crete; and the Helladic, including the Mycenaean, on the mainland. *(page 90)*

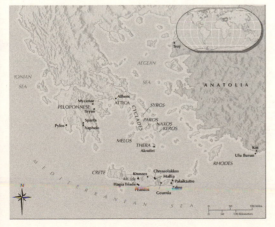

THE CYCLADIC ISLANDS
IN THE BRONZE AGE

4-2. Incised panel (Frying Pan), from Syros,
Cyclades. c. 2500–2200 BCE. *(page 92)*

4-3. Two figures of women, from the
Cyclades. c. 2500–2200 BCE. *(page 92)*

4-4. *Seated Harp Player,* from Keros, Cyclades.
c. 2800–2700 BCE. *(page 93)*

CRETE AND THE MINOAN CIVILIZATION

Pioneers of Aegean Archaeology

American archaeologist Harriet Boyd Hawes,
photographed on Crete in 1902. *(page 94)*

4-5. Reconstruction of the palace complex, Knossos, Crete, during the Second Palace period. Site occupied 2000–1375 BCE; complex begun in Old Palace period (c. 1900–1700 BCE). *(page 95)*

THE OLD PALACE PERIOD (c. 1900–1700 BCE)

4-6. Kamares ware jug, from Phaistos, Crete. Old Palace period, c. 2000–1900 BCE. *(page 96)*

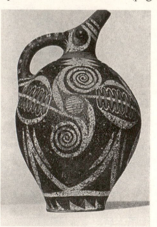

4-7. Pendant of gold bees, from Chryssolakkos,
near Mallia, Crete. Old Palace period, c. 1700–1500 BCE.
(page 97)

THE SECOND PALACE PERIOD
(c. 1700–1450 BCE)

**4-8. Court with staircase reconstructed by
Sir Arthur Evans,** leading to the southeast
residential quarter, palace complex, Knossos, Crete.
(page 98)

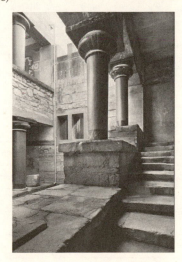

4-9. *Woman or Goddess with Snakes,* as restored, from the palace complex, Knossos, Crete. Second Palace period, c. 1700–1550 BCE. *(page 98)*

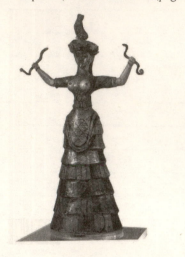

4-10. *Harvester Vase,* from Hagia Triada, Crete. Second Palace period, c. 1650–1450 BCE. *(page 99)*

4-11. Bull's-head rhyton, from the palace complex, Knossos, Crete. Second Palace period, c. 1550–1450 BCE. *(page 99)*

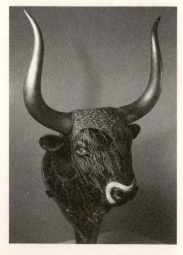

4-12. *Octopus Flask,* from Palaikastro, Crete. Second Palace period, c. 1500–1450 BCE. *(page 100)*

4-13. *Young Girl Gathering Saffron Crocus Flowers,* detail of wall painting, Room 3 of House Xeste 3, Akrotiri, Thera. Second Palace period, c. 1700–1450 BCE. *(page 101)*

LATE MINOAN PERIOD
(c. 1450–1100 BCE)

4-14. *Landscape (Spring Fresco)*, wall painting with areas of modern reconstruction, from Akrotiri, Thera Cyclades. Before 1630–1500 BCE. *(page 102)*

4-15. *Bull Leaping*, wall painting with areas of modern reconstruction, from the palace complex, Knossos, Crete. Late Minoan period, c. 1540–1450 BCE. *(page 103)*

4-16. *Vapheio Cup,* found near Sparta, Greece.
c. 1650–1450 BCE. *(page 103)*

MAINLAND GREECE AND THE MYCENAEAN CIVILIZATION

ARCHITECTURE

4-17. Citadel, Mycenae, Greece. Site occupied
c. 1600–1200 BCE; walls built c. 1340, 1250, 1200 BCE.
(page 104)

4-18. Lion Gate, Mycenae. C. 1250 BCE.
(page 104)

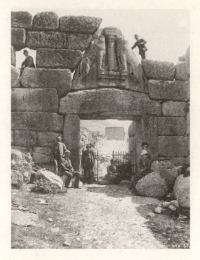

The Object Speaks:
The "Mask of Agamemnon"

4-19. *"Mask of Agamemnon,"* funerary mask,
from the royal tombs, Grave Circle A, Mycenae,
Greece. c. 1600–1550 BCE. *(page 106)*

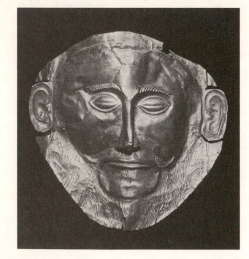

4-20. *Tholos*, **the so-called Treasury of Atreus,**
Mycenae, Greece. c. 1300–1200 BCE. *(page 107)*

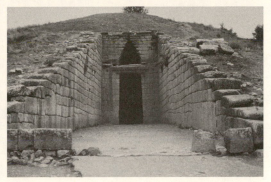

**4-21. Cutaway drawing, the so-called
Treasury of Atreus.** *(page 107)*

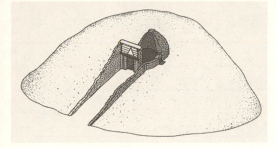

**4-22. Corbeled vault, interior of the
so-called Treasury of Atreus.** *(page 107)*

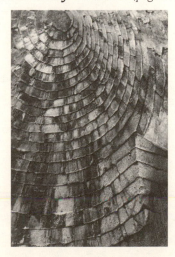

4-23. Plan of the citadel at Tiryns, Greece. Site
occupied c. 1600–1200 BCE; fortified c. 1365 BCE. *(page 108)*

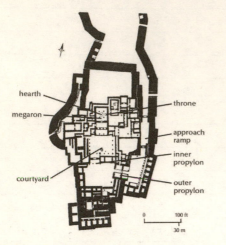

4-24. Corbel-vaulted casemate inside the ring
wall of the citadel at Tiryns. c. 1365 BCE. *(page 108)*

**4-25. Reconstruction drawing of the
megaron in the palace at Pylos,** Greece.
c. 1300–1200 BCE. *(page 109)*

SCULPTURE

4-26. *Two Women with a Child,* found in the palace
at Mycenae, Greece, c. 1400–1200 BCE. *(page 110)*

METALWORK

4-27. Dagger blade with lion hunt, from
Shaft Grave IV, Grave Circle A, Mycenae, Greece.
c. 1550–1500 BCE. *(page 111)*

CERAMICS

4-28. *Warrior Vase* from Mycenae, Greece.
c. 1300–1100 BCE. *(page 111)*

5

ART OF ANCIENT GREECE

5-1. Myron. *Discus Thrower (Diskobolos).* Roman copy after the original bronze of c. 450 BCE. *(page 113)*

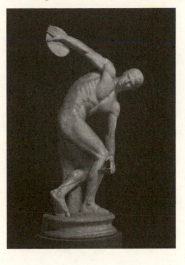

THE EMERGENCE OF GREEK CIVILIZATION

Map 5-1. Ancient Greece. During the Hellenistic period, Greek influence extended beyond mainland Greece to Macedonia, Egypt, and Asia Minor. *(page 114)*

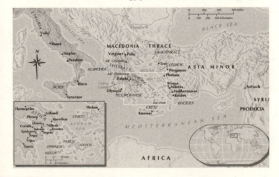

A BRIEF HISTORY

RELIGIOUS BELIEFS
AND SACRED PLACES

5-2. Sanctuary of Apollo, Delphi. 6th–3rd
century BCE. *(page 117)*

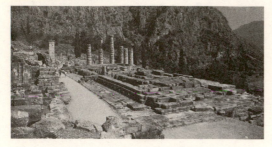

**5-3. Reconstruction drawing of the Sanctuary
of Apollo, Delphi.** c. 400 BCE. *(page 117)*

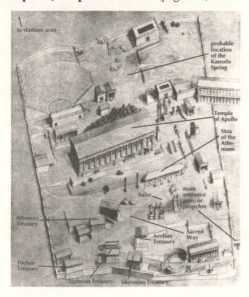

HISTORICAL DIVISIONS OF GREEK ART

THE GEOMETRIC PERIOD

CERAMIC DECORATION

5-4. *Centaur*, from Lefkandi, Euboea. Late 10th century BCE. *(page 119)*

5-5. Funerary vase (Krater), from the Dipylon Cemetery, Athens. c. 750–750 BCE. *(page 119)*

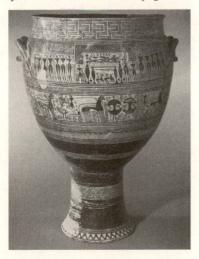

METAL SCULPTURE

5-6. *Man and Centaur,* perhaps from Olympia.
c. 750 BCE. *(page 120)*

THE FIRST GREEK TEMPLES

5-7. Model of a temple, found in the Sanctuary
of Hera, Argos. Mid-8th century BCE. *(page 121)*

THE ORIENTALIZING PERIOD

5-8. Pitcher (olpe), from Corinth. c. 600 BCE.
(page 121)

THE ARCHAIC PERIOD

TEMPLE ARCHITECTURE

5-9. Temple of Hera I, Paestum, Italy. c. 550 BCE.
(page 122)

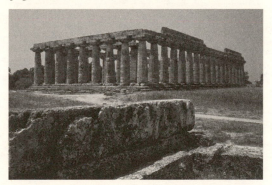

5-10. Corner view of the Temple of Hera I, Paestum. *(page 122)*

Elements of Architecture:
Greek Temple Plans

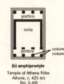
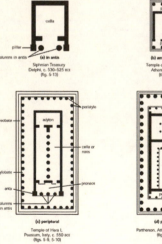
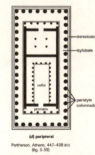

(a) in antis
Siphnian Treasury
Delphi, c. 530–525 BCE
(fig. 5-13)

(b) amphiprostyle
Temple of Athena Nike
Athens, c. 425 BCE
(fig. 5-46)

(c) peripteral
Temple of Hera I,
Paestum, Italy, c. 550 BCE
(figs. 5-9, 5-10)

(d) peripteral
Parthenon, Athens, 447–438 BCE
(fig. 5-39)

Elements of Architecture:
The Greek Architectural Orders

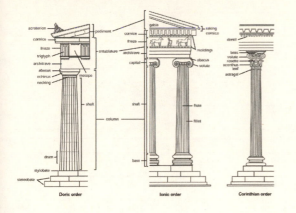

ARCHITECTURAL SCULPTURE

5-11. Reconstruction of the west pediment of the Temple of Artemis, Korkyra (Corfu), after G. Rodenwaldt. c. 600–580 BCE. *(page 125)*

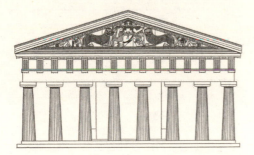

5-12. *Gorgon Medusa,* detail of sculpture from the west pediment of the Temple of Artemis, Korkyra. c. 580 BCE. *(page 125)*

5-13. Reconstruction of the Treasury of the Siphnians, Delphi, using fragments found in the Sanctuary of Apollo, Delphi. c. 530–525 BCE. *(page 126)*

5-14. *Battle between the Gods and the Giants,* fragments of the north frieze of the Treasury of the Siphnians, from the Sanctuary of Apollo, Delphi. c. 530–525 BCE. *(page 126)*

5-15. Reconstruction drawing of the east pediment of the Temple of Aphaia, Aegina. c. 490 BCE. *(page 127)*

5-16. *Dying Warrior,* sculpture from the left corner of the east pediment of the Temple of Aphaia, Aegina. c. 480 BCE. *(page 127)*

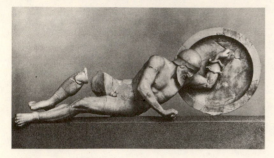

FREESTANDING SCULPTURE

5-17. *Standing Youth (Kouros),* from Attica. c. 580 BCE. *(page 128)*

5-18. *Anavysos Kouros,* perhaps young Kroisos, from a cemetery at Anavysos, near Athens. c. 530 BCE. *(page 128)*

5-19. *Berlin Kore,* from a cemetery at Keratea, near Athens. 570–560 BCE. *(page 129)*

5-20. *Peplos Kore,* from the Acropolis, Athens. c. 530 BCE. *(page 130)*

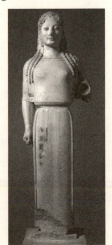

5-21. *Kore*, **from Chios (?).** C. 520 BCE. *(page 130)*

5-22. *Calf Bearer (Moschophoros)***,** from the Acropolis, Athens. C. 560 BCE. *(page 131)*

5-23. Standard shapes of Greek vessels. *(page 132)*

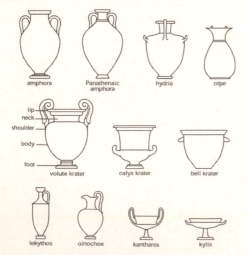

amphora Panathenaic amphora hydria olpe

lip
neck
shoulder
body
foot
volute krater calyx krater bell krater

lekythos oinochoe kantharos kylix

VASE PAINTING

5-24. Ergotimos (potter) and Kleitias (painter). *François Vase.* c. 570 BCE. *(page 132)*

5-25. Amasis Painter. *Dionysos with Maenads.* c. 540 BCE. *(page 132)*

5-26. Exekias. *The Suicide of Ajax,* c. 540 BCE.
(page 134)

5-27. **The Priam Painter.** *Women at a Fountain House.* 520–510 BCE. *(page 135)*

5-28. Euphronios (painter) and Euxitheos (potter). *Death of Sarpedon.* c. 515 BCE. *(page 136)*

5-29. Foundry Painter. *A Bronze Foundry*, red-figure decoration on a kylix from Vulci, Italy. 490–480 BCE. *(page 137)*

THE CLASSICAL PERIOD IN GREEK ART

THE EARLY CLASSICAL PERIOD

ARCHITECTURAL SCULPTURE

5-30. Reconstruction drawing of the west pediment of the Temple of Zeus, Olympia. c. 470–456 BCE. *(page 138)*

5-31. *Apollo with Battling Lapiths and Centaurs,* fragments of sculpture from the west pediment of the Temple of Zeus, Olympia. c. 460 BCE. *(page 138)*

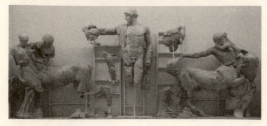

5-32. *Athena, Herakles, and Atlas,* metope relief from the frieze of the Temple of Zeus, Olympia. c. 460 BCE. *(page 139)*

FREESTANDING SCULPTURE

5-33. *Kritian Boy,* from Acropolis, Athens. c. 480 BCE.
(page 140)

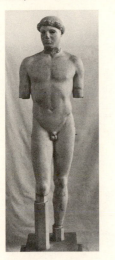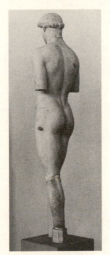

5-34. *Charioteer,* from the Sanctuary of Apollo,
Delphi. c. 470 BCE. *(page 141)*

5-35. *Warrior A,* found in the sea off Riace, Italy.
c. 460–450 BCE. *(page 141)*

VASE PAINTING

5-36. Pan Painter. *Artemis Slaying Actaeon.*
c. 470 BCE. *(page 143)*

THE MATURE CLASSICAL PERIOD

The Discovery and Conservation of the Riace *Warriors*

Back of *Warrior A* from Riace prior to conservation. Museo Archeològico Nazionale, Reggio Calabria, Italy. *(page 144)*

The Canon of Polykleitos

Polykleitos. *Achilles*, also known as *Spear Bearer (Doryphoros)*, Roman copy after the original bronze of c. 450–440 BCE. *(page 145)*

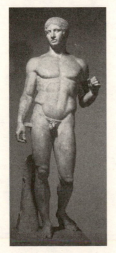

THE ATHENIAN AGORA

**5-37. Plan of the Agora (marketplace),
Athens.** c. 400 BCE. *(page 146)*

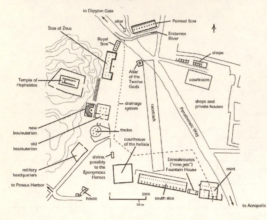

THE ACROPOLIS

5-38. Model of the Acropolis, Athens, c. 400
BCE. Royal Ontario Museum, Toronto. *(page 147)*

The Object Speaks:
The Parthenon

5-39. Kallikrates and Iktinos. Parthenon, Acropolis, Athens. 447–438 BCE. *(page 148)*

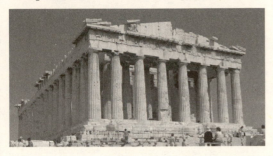

5-40. William Pars. The Parthenon when it contained a mosque. Drawn in 1765 and published in James Stuart and Nicholas Revett, *The Antiquities of Athens* (London, 1789). *(page 149)*

5-41. William Strickland. The Second Bank of the United States, Philadelphia. 1818–24. Watercolor by A. J. Davis. Avery Architecture and Fine Arts Library, Columbia University, New York. *(page 149)*

5-42. Photographic mock-up of the east pediment of the Parthenon (using photographs of the extant marble sculpture c. 438–432 BCE). *(page 150)*

5-43. *Lapith Fighting a Centaur,* metope relief
from the Doric frieze on the south side of the
Parthenon. c. 440s BCE. *(page 151)*

**5-44. View of the outer Doric and inner
Ionic friezes at the west end of the
Parthenon.** c. 440s–430s BCE. *(page 151)*

5-45. *Horsemen,* detail of the *Procession,* from
the Ionic frieze on the north side of the Parthenon.
c. 438–432 BCE. *(page 152)*

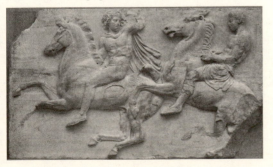

5-46. *Marshals and Young Women,* detail of the Procession, from the Ionic frieze on the east side of the Parthenon. c. 438– 432 BCE. *(page 152)*

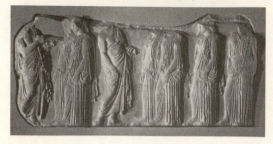

5-47. Mnesikles. Erechtheion, Acropolis, Athens. 430s–405 BCE. *(page 153)*

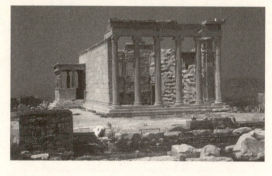

5-48. Porch of the Maidens (Caryatid Porch), Erechtheion, Acropolis, Athens. 421–405 BCE. *(page 154)*

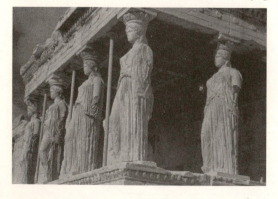

5-49. Kallikrates. Temple of Athena Nike, Acropolis, Athens. C. 425 BCE. *(page 154)*

5-50. *Nike (Victory) Adjusting Her Sandal*, fragment of relief decoration from the parapet (now destroyed), Temple of Athena Nike, Acropolis, Athens. Last quarter of the 5th century BCE. *(page 155)*

STELE SCULPTURE

5-51. *Grave Stele of Hegeso.* c. 410–400 BCE.
(page 156)

PAINTING

5-52. Style of Achilles Painter. *Woman and Maid.* c. 450–440 BCE. *(page 157)*

THE LATE CLASSICAL PERIOD

ARCHITECTURE AND ARCHITECTURAL SCULPTURE

5-53. Plan of Miletos, Ionia (modern Turkey), with original coastline. *(page 158)*

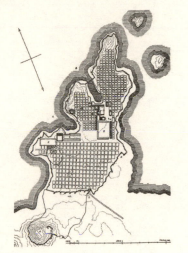

5-54. *Tholos*, Sanctuary of Athena Pronaia, Delphi. c. 400 BCE. *(page 159)*

5-55. Plan and section of the *tholos*, Sanctuary of Athena Pronaia, Delphi. *(page 159*

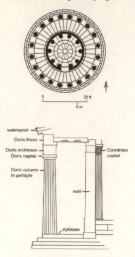

5-56. Reconstruction drawing of the Mausoleum (tomb of Mausolos), Halikarnassos (modern Bodrum, Turkey). c. 350 BCE. *(page 159)*

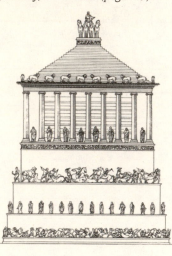

5-57. *Mausolos (?)*, from the Mausoleum (tomb of Mausolos), Halikarnassos, c. 350 BCE. *(page 160)*

SCULPTURE

5-58. Skopas (?). Panel from the Amazon frieze, south side of the Mausoleum at Halikarnassos. Mid-4th century BCE. *(page 161)*

5-59. Praxiteles or his followers. *Hermes and the Infant Dionysos,* a Hellenistic or Roman copy after a Late Classical 4th-century BCE original. *(page 161)*

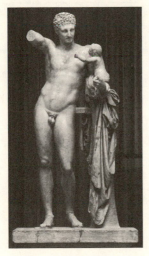

5-60. Praxiteles. *Aphrodite of Knidos,* composite of two similar Roman copies after the original marble of c. 350 BCE. *(page 162)*

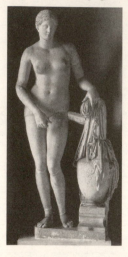

5-61. Lysippos. *The Scraper (Apoxyomenos),* Roman copy after the original bronze of c. 330 BCE. *(page 163)*

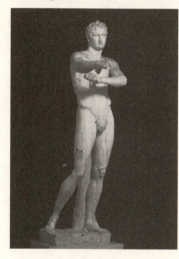

5-62. Lysippos (?). *Alexander the Great,* head from a Hellenistic copy (c. 200 BCE) of a statue, possibly after a 4th-century BCE original. *(page 164)*

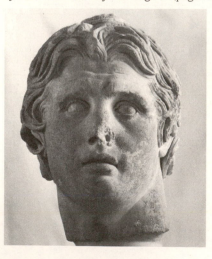

5-63. *Alexander the Great,* 4-drachma coin issued by Lysimachos of Thrace. 306–281 BCE. *(page 165)*

WALL PAINTING AND MOSAICS

5-64. Facade of Tomb II, so-called Tomb of Philip II, Vergina, Macedonia. Second half of the 4th century BCE. *(page 165)*

5-65. *Abduction of Persephone,* detail of a
wall painting in Tomb I (Small Tomb), Vergina,
Macedonia. c. 366 BCE. *(page 165)*

5-66. *Alexander the Great Confronts Darius III at
the Battle of Issos,* detail of mosaic floor decoration
from Pompeii, Italy. 1st century CE *(page 166)*

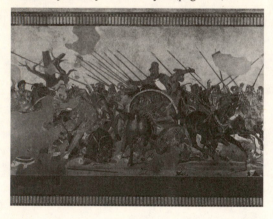

5-67. Gnosis. *Stag Hunt,* detail of mosaic floor
decoration from Pella, Macedonia. 300 BCE. *(page 167)*

THE ART OF THE GOLDSMITH

5-68. Earrings. c. 330–300 BCE. *(page 167)*

Women Artists in Ancient Greece

***A Vase Painter and Assistants Crowned by
Athena and Victories,*** composite photograph of
the red-figure decoration on a hydria from Athens.
c. 450 BCE. *(page 168)*

5-69. Pectoral, from the tomb of a Scythian at Ordzhonikidze, Russia. 4th century BCE. *(page 168)*

THE HELLENISTIC PERIOD

THEATERS

5-70. Theater, Epidauros. Early 3rd century BCE and later. *(page 170)*

5-71. Plan of the theater at Epidauros.
(page 170)

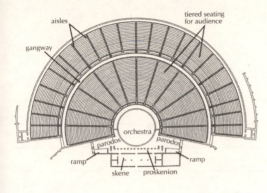

THE CORINTHIAN ORDER
IN ARCHITECTURE

5-72. Temple of the Olympian Zeus, Athens.
Building and rebuilding phases: foundation
c. 520–510 BCE using the Doric order; temple
designed by Cossutius, begun 175 BCE, left unfinished
164 BCE, completed 132 CE using Cossutius's design
and the Corinthian order (see fig. 26, Introduction).
(page 170)

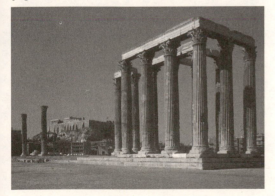

SCULPTURE

5-73. *Gallic Chieftain Killing His Wife and Himself,* Roman copy after the original bronze of c. 220 BCE. *(page 171)*

5-74. Epigonos (?). *Dying Gallic Trumpeter,* Roman copy after the original bronze of c. 220 BCE. *(page 172)*

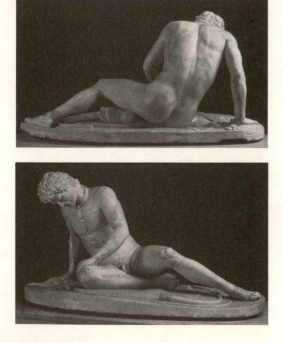

5-75. Reconstructed west front of the altar from Pergamon, Turke. c. 175–150 BCE. *(page 173)*

5-76. *Athena Attacking the Giants*, detail of the frieze from the east front of the altar from Pergamon 164–156 BCE. *(page 173)*

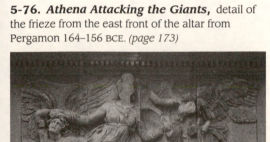

5-77. Hagesandros, Polydoros, and Athanadoros of Rhodes. *Laocoön and His Sons.* Hellenistic, 2nd–1st century BCE or a Roman copy of the 1st century CE. *(page 174)*

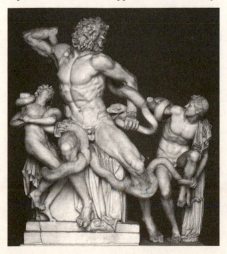

5-78. *Nike (Victory) of Samothrace,* from the
Sanctuary of the Great Gods, Samothrace. c. 190 BCE (?).
(page 175)

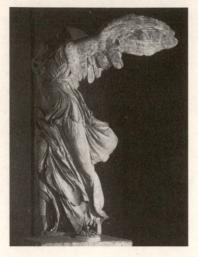

5-79. *Veiled and Masked Dancer.* Late 3rd or
2nd century BCE. *(page 176)*

5-80. *Old Woman.* 2nd century BCE. *(page 176)*

5-81. *Aphrodite of Melos* **(also called** *Venus de Milo***).** c. 150–125 BCE. *(page 177)*

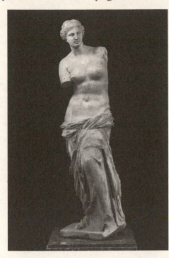

5-82. *Hellenistic Ruler.* c. 150–140 BCE. *(page 178)*

6
ETRUSCAN ART
AND ROMAN ART

6-1. *She-Wolf.* C. 500 BCE, with 15th century additions (twins). *(page 181)*

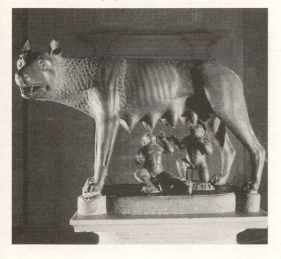

Map 6-1. The Roman Republic and Empire.
After defeating the Etruscans in 509 BCE, Rome became a republic. It reached its greatest area by the time of Julius Caesar's death in 46 BCE. *(page 182)*

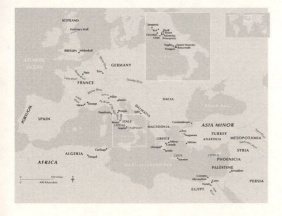

ETRUSCAN CIVILIZATION

THE ETRUSCAN CITY

6-2. Porta Augusta, Perugia, Italy. 2nd century BCE.
(page 183)

TEMPLES AND THEIR
DECORATION

6-3. Reconstruction of an Etruscan temple,
based partly on descriptions by Vitruvius. University
of Rome, Istituto di Etruscologia e Antichità Italiche.
(page 184)

6-4. Plan of an Etruscan temple, based partly on descriptions by Vitruvius. *(page 184)*

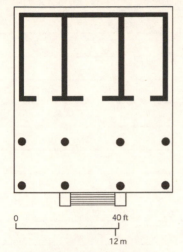

0 40 ft

12 m

6-5. Apollo, from Veii. C. 500 BCE. *(page 185)*

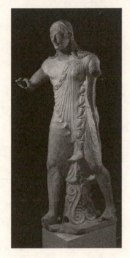

Elements of Architecture: Arch, Vault, and Dome

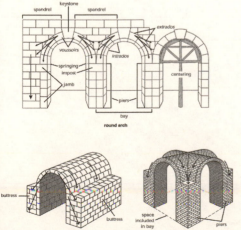

Roman Writers on Art

Elements of Architecture:
Roman Architectural Orders

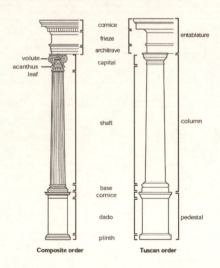

Composite order Tuscan order

TOMBS

6-6. Etruscan cemetery of La Banditaccia, Cerveteri. 7th–4th century BCE. *(page 188)*

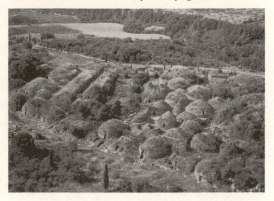

6-7. Burial chamber, Tomb of the Reliefs, Cerveteri. 3rd century BCE. *(page 188)*

6-8. Sarcophagus, from Cerveteri. c. 520 BCE. *(page 189)*

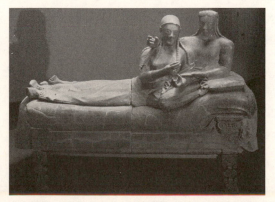

6-9. *Musicians and Dancers,* detail of a wall painting, Tomb of the Lionesses, Tarquinia. c. 480–470 BCE. *(page 190)*

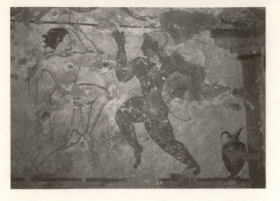

BRONZE WORK

6-10. Head of a man. c. 300 BCE. *(page 191)*

6-11. Mirror. c. 350 BCE. *(page 191)*

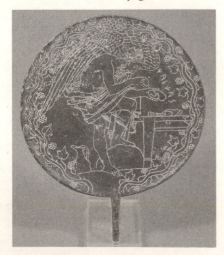

ROME

ORIGINS OF ROME

ROMAN RELIGION

Distinctively Roman Gods

Chapter 5 (page 118) gives a comprehensive list of
Greek gods and their Roman counterparts. The Ro-
mans, however, honored some deities that were not
found in Greece. They include:

Fortuna	goddess of fate (fortune)
Priapus	god of fertility
Saturn	god of harvests
Janus	god of beginnings and endings; has two faces, enabling him to look forward and backward
Pomona	goddess of gardens and orchards
Terminus	god of boundaries

THE ROMAN REPUBLIC

REPUBLICAN SCULPTURE

6-12. *Aulus Metellus,* found near Perugia. Late
2nd or early 1st century BCE. *(page 193)*

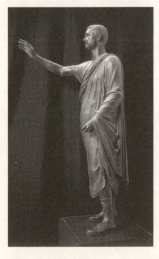

6-13. *Denarius* **with portrait of Julius Caesar.** 44 BCE. *(page 193)*

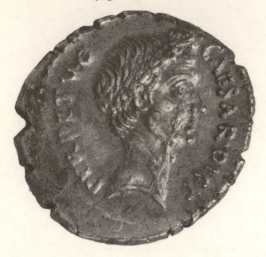

Roman Funerary Practices

ARCHITECTURE

Elements of Architecture:
Roman Construction

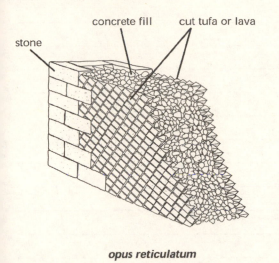

stone

concrete fill

cut tufa or lava

opus reticulatum

**6-14. Model of the Sanctuary of Fortuna
Primigenia, Palestrina,** Italy. Begun c. 100 BCE.
(page 195)

6-15. Temple perhaps dedicated to Portunus, Forum Boarium (Cattle Market), Rome. Late 2nd century BCE. *(page 196)*

6-16. Plan of temple perhaps dedicated to Portunus. *(page 196)*

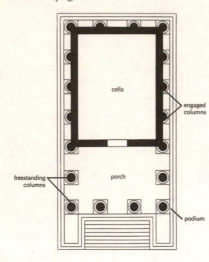

THE EARLY EMPIRE

Reigns of Significant Roman Emperors

	Augustus	27 BCE–14 CE
Julio-Claudian	Tiberius	14–37 CE
	Caligula	37–41
	Claudius	41–54
	Nero	54–68
Flavian	Vespasian	69–79
	Titus	79–81
	Domitian	81–96
The "Five Good Emperors"	Nerva	96–98
	Trajan	98–117
	Hadrian	117–138
Antonine	Antoninus Pius	138–161
	Marcus Aurelius	161–180
	Commodus	180–192
Severan	Septimius Severus	193–211
	Caracalla	211–217
	Severus Alexander	222–235
	Diocletian	284–305
	Constantine I	306–337

AUGUSTAN SCULPTURE

6-17. *Augustus of Primaporta.* Early 1st century CE (perhaps a copy of a bronze statue of c. 20 BCE). *(page 197)*

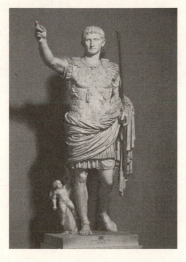

Notes

6-18. *Livia.* C. 20 BCE. *(page 198)*

6-19. Ara Pacis Augustae (Altar of Augustan Peace), Rome. 13–9 BCE. *(page 199)*

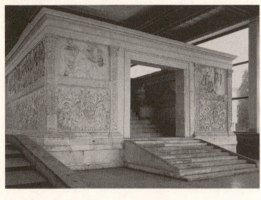

6-20. *Imperial Procession,* detail of a relief on the south side of the Ara Pacis. *(page 200)*

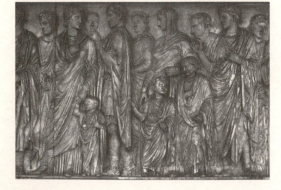

6-21. *Allegory of Peace,* relief on the east side
of the Ara Pacis. *(page 200)*

6-22. *Gemma Augustea.* Early 1st century CE.
(page 201)

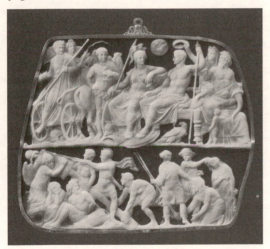

ARCHITECTURE

6-23. Pont du Gard, Nîmes, France. Late 1st century BCE. *(page 202)*

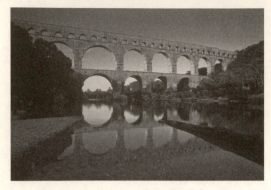

6-24. Maison Carrée, Nîmes, France. c. 20 BCE. *(page 202)*

6-25. Roman theater, Orange, France. 1st century BCE. *(page 203)*

THE ROMAN CITY AND HOME

6-26. Plan of the city of Pompeii in 79 CE. *(page 204)*

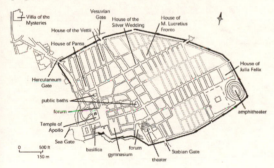

6-27. Plan of a typical Roman house.
(page 204)

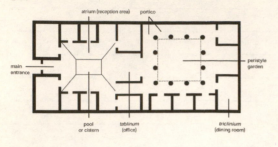

6-28. Atrium, House of the Silver Wedding, Pompeii. Early 1st century CE. *(page 205)*

6-29. Peristyle garden, House of the Vettii, Pompeii. 2nd century BCE, rebuilt 60–79 BCE. *(page 206)*

WALL PAINTING

6-30. Reconstructed bedroom, from the House of Publius Fannius Synistor, Boscoreale, near Pompeii. Late 1st century CE, with later furnishings. The Metropolitan Museum of Art, New York. *(page 206)*

The Urban Garden

Wall niche, from a garden in Pompeii Mid-1st century CE. *(page 207)*

6-31. *Cityscape,* detail of a wall painting from a bedroom in the House of Publius Fannius Synistor, Boscoreale. Late 1st century CE. *(page 208)*

6-32. *Garden Scene,* detail of a wall painting from the Villa of Livia at Primaporta, near Rome. Late 1st century BCE. *(page 208)*

6-33. *Seascape,* detail of a wall painting from Villa Farnesina, Rome. Late 1st century CE. *(page 209)*

6-34. *Initiation Rites of the Cult of Bacchus (?),* detail of a wall painting in the Villa of the Mysteries, Pompeii. c. 50 BCE. *(page 209)*

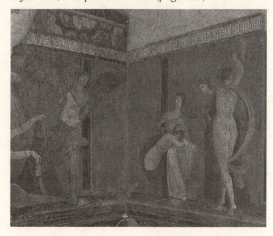

6-35. *Still Life,* detail of a wall painting from Herculaneum. c. 62–79 CE. *(page 210)*

6-36. *Young Woman Writing,* detail of a wall painting, from Pompeii. Late 1st century CE. *(page 210)*

6-37. Detail of a wall painting in the House of M. Lucretius Fronto, Pompeii. Mid-1st century CE.*(page 211)*

IMPERIAL ROME

6-38. Model of the Forum Romanum and Imperial Forums, Rome. c. 325 CE. *(page 212)*

IMPERIAL ARCHITECTURE

6-39. Restored perspective view of the central hall, Basilica Ulpia, Rome. 113 CE. *(page 213)*

6-40. Main hall, Markets of Trajan, Rome. 100–12 CE. *(page 214)*

6-41. Market Gate, from Miletos (Turkey).
c. 120 CE. *(page 215)*

6-42. Colosseum, Rome. 72–80 CE. *(page 215)*

6-43. Colosseum. View of a radial passage with barrel and groin vaulting. *(page 216)*

6-44. Colosseum. *(page 216)*

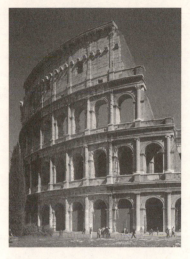

6-45. Pantheon, Rome c. 118–128 CE. *(page 217)*

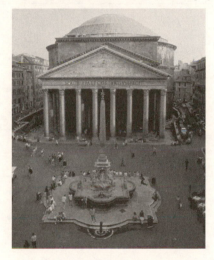

6-46. Reconstruction drawing of the Pantheon. *(page 218)*

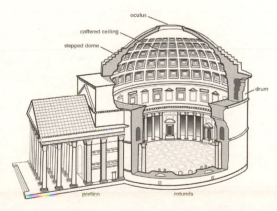

6-47. Dome of the Pantheon with light
from the oculus on its coffered ceiling. 125–128
CE. *(page 218)*

6-48. Model of Hadrian's Villa, Tivoli.
c. 125–38 CE. *(page 219)*

MOSAICS

6-49. Canopus, Hadrian's Villa, Tivoli.
c. 130–35 CE. *(page 220)*

6-50. *Battle of Centaurs and Wild Beasts*,
from Hadrian's Villa, Tivoli. c. 118–28 CE. *(page 220)*

Technique:
Roman Mosaics

The Object Speaks:
The Unswept Floor

6-51. Herakleitos. *The Unswept Floor*,
mosaic variant of a 2nd-century BCE painting by
Sosos of Pergamon. 2nd century CE. *(page 221)*

THE URBAN PLAN

6-52. Hadrian's Wall, Great Britain. 2nd
century CE. *(page 222)*

6-53. Ruins of Timgad, Algeria. Begun c. 100 CE.
(page 223)

6-54. Plan of Timgad. *(page 223)*

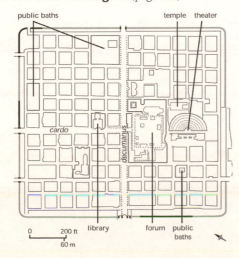

6-55. Apartment block (*insula*), Ostia.
1st–2nd century CE. *(page 224)*

MONUMENTAL SCULPTURE

6-56. Arch of Titus, Rome c. 81 CE. *(page 225)*

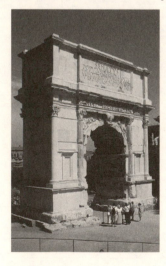

6-57. *Spoils from the Temple of Solomon, Jerusalem,* relief in the passageway of the Arch of Titus. *(page 226)*

6-58. Column of Trajan, Rome. 113–16 or after 117 CE. *(page 227)*

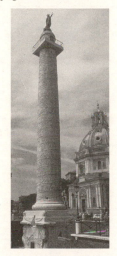

6-59. *Romans Crossing the Danube and Building a Fort,* detail of the lowest part of the Column of Trajan. 113–16 CE or after 117. *(page 228)*

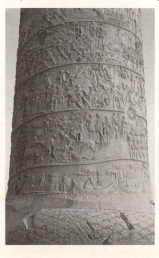

6-60. *Hadrian Hunting Boar and Sacrificing to Apollo,* roundels made for a monument to Hadrian and reused on the Arch of Constantine. Sculpture c. 130–38 CE. *(page 229)*

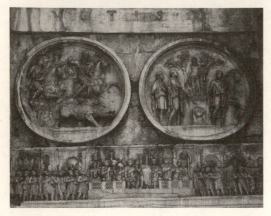

6-61. *Mausoleum under Construction,* relief from the tomb of the Haterius family, Via Labicana, Rome. Late 1st century CE. *(page 229)*

PORTRAIT SCULPTURE

6-62. *Young Flavian Woman.* c. 90 CE.
(page 230)

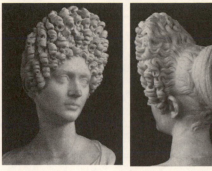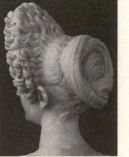

6-63. *Middle-Aged Flavian Woman.* Late 1st
century CE. *(page 231)*

The Position of Roman Women

6-64. *Antinous,* from Hadrian's Villa at Tivoli.
c. 130–38 CE. *(page 231)*

6-65. Equestrian statue of Marcus Aurelius
(after restoration). c. 176 CE. *(page 232)*

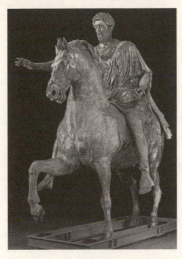

6-66. *Commodus as Hercules*, from Esquiline
Hill, Rome. c. 191–92 CE. *(page 233)*

THE LATE EMPIRE

THE SEVERAN DYNASTY

6-67. *Septimius Severus, Julia Domna, and Their Children, Geta and Caracalla,* from Fayum, Egypt. c. 200 CE. *(page 234)*

6-68. *Caracalla.* Early 3rd century CE. *(page 235)*

6-69. Baths of Caracalla, Rome. c. 211–17 CE. *(page 235)*

6-70. Plan of the Baths of Caracalla. *(page 236)*

gymnasium

gymnasium

natatio (swimming pool)

caldarium (hot bath)

frigidarium (cold bath)

tepidarium (warm bath)

0 150 ft

40 m

6-71. McKim, Mead, and White, architects. Waiting room, interior of New York City's Pennsylvania Railroad Station. 1906–10; demolished 1963. *(page 236)*

THE THIRD CENTURY

6-72. *Philip the Arab.* 244–49 CE. *(page 237*

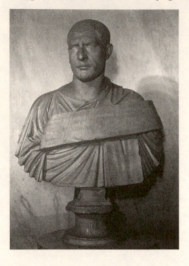

6-73. *Family Group,* traditionally called the *Family of Vunnerius Keramus.* c. 250 CE. *(page 237)*

Notes

6-74. *Battle between the Romans and the Barbarians,* detail of the *Ludovisi Battle Sarcophagus,* found near Rome. C. 250 CE. *(page 238)*

THE TETRARCHS

6-75. *The Tetrarchs.* C. 300 CE. *(page 239)*

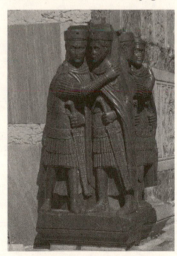

CONSTANTINE THE GREAT
AND HIS LEGACY

6-76. Model of Palace of Diocletian, Split,
Croatia. c. 300 CE. *(page 240)*

6-77. Peristyle court, Palace of Diocletian.
(page 240)

Notes

6-78. Former audience hall, now known as the Basilica, Trier, Germany. Early 4th century. *(page 241)*

6-79. Arch of Constantine, Rome. 312–15 CE (dedicated July 25, 315). *(page 241)*

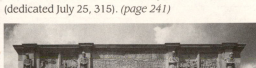
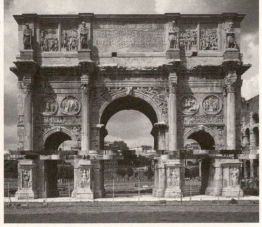

6-80. Basilica of Maxentius and Constantine (Basilica Nova), Rome. 306–13 CE.*(page 243)*

6-81. Plan and isometric projection of the Basilica of Maxentius and Constantine (Basilica Nova). *(page 243)*

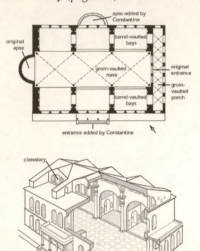

6-82. *Constantine the Great*, from the Basilica of Maxentius and Constantine, Rome. 325–26 CE. *(page 244)*

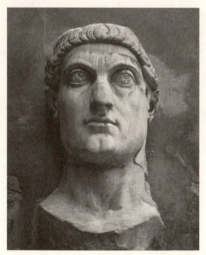

ROMAN TRADITIONALISM
IN ART AFTER CONSTANTINE

6-83. *Julian the Apostate,* coin issued 361–63 CE.
(page 244)

6-84. *Priestess of Bacchus* **(?),** right panel of a
diptych. c. 390–401 CE. *(page 245)*

6-85. Dish, from Mildenhall, England. Mid-
4th century CE. *(page 246)*

7

JEWISH, EARLY CHRISTIAN, AND BYZANTINE ART

Notes

7-1. *Cubiculum* of Leonis, Catacomb of Commodilla, near Rome. Late 4th century. *(page 248)*

JEWS AND CHRISTIANS IN THE ROMAN EMPIRE

Map 7-1. Early Jewish, Christian, and Byzantine Worlds.
The eastern Mediterranean lands of Canaan and Judaea were centers of Jewish settlement. Rome was a major center of early Christianity. Byzantine culture took root in Constantinople and flourished throughout the Eastern Roman, or Byzantine, Empire and extended into northern areas such as Russia and Ukraine. *(page 250)*

EARLY JUDAISM

EARLY JEWISH ART

7-2. *Menorahs and Ark of the Covenant*,
wall painting in a Jewish catacomb, Villa Torlonia,
Rome. 3rd century. *(page 250)*

7-3. Wall with Torah niche, from a house-
synagogue, Dura-Europos, Syria. 244–45. *(page 252)*

7-4. *The Finding of the Baby Moses,* detail of a
wall painting from a house-synagogue, Dura-Europos,
Syria. 244–45. *(page 252)*

7-5. Mosaic synagogue floor, from Maon
(Menois). c. 530. *(page 253)*

EARLY CHRISTIANITY

EARLY CHRISTIAN ART

7-6. *Good Shepherd, Orants*, and *Story of Jonah*, painted ceiling of the Catacomb of Saints Pietro and Marcellino, Rome. Late 3rd–early 4th century. *(page 254)*

Rome, Constantinople, and Christianity

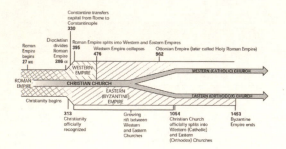

Christian Symbols

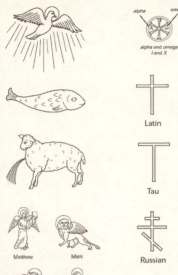

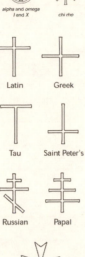

7-7. *Jonah Swallowed and Jonah Cast Up,*
two statuettes of a group from the eastern
Mediterranean, probably Asia Minor. Probably 3rd
century. *(page 257)*

7-8. Small-scale model of walls and baptismal font, from the baptistry of a Christian house-church, Dura-Europos, Syria. c. 240. *(page 257)*

IMPERIAL CHRISTIAN ARCHITECTURE AND ART

ARCHITECTURE AND ITS DECORATION

Elements of Architecture: Basilica-Plan and Central-Plan Churches

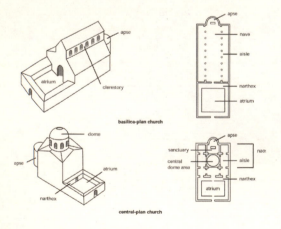

basilica-plan church

central-plan church

Notes

7-9. Reconstruction drawing of Old Saint Peter's basilica, Rome. c. 320–27; atrium added in later 4th century. *(page 259)*

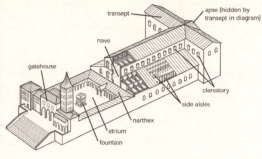

7-10. Church of Santa Sabina, Rome.
Exterior view 422–32. *(page 260)*

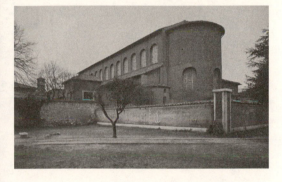

7-11. Interior, Church of Santa Sabina. View from the sanctuary to the entrance. c. 422–32.*(page 260)*

7-12. *Parting of Lot and Abraham,* mosaic in
the nave arcade, Church of Santa Maria Maggiore,
Rome. 432–40. *(page 261)*

CENTRAL-PLAN CHURCHES

**7-13. Plan and section of the Church of
Santa Costanza, Rome.** c. 338–50. *(page 261)*

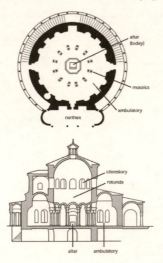

7-14. Santa Costanza. View through ambulatory into the rotunda. *(page 262)*

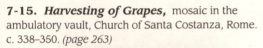

7-15. *Harvesting of Grapes,* mosaic in the ambulatory vault, Church of Santa Costanza, Rome. c. 338–350. *(page 263)*

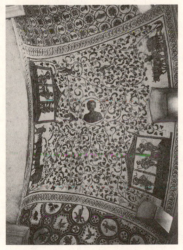

7-16. Mausoleum of Galla Placidia, Ravenna, Italy. c. 425–26. *(page 263)*

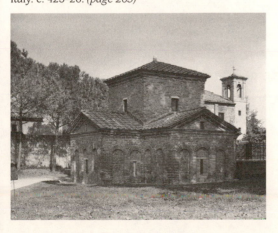

7-17. Mausoleum of Galla Placidia, eastern
bays with sarcophagus niches in the arms and
lunette mosaic of the *Martyrdom of Saint Lawrence*
(page 264)

7-18. *Good Shepherd*, mosaic in the lunette
over the entrance, Mausoleum of Galla Placidia.
(page 265)

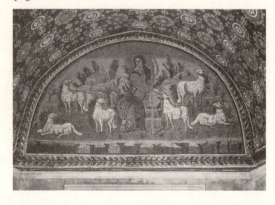

Early Forms of the Book

Bookstand with the Gospels in codex form,
detail of a mosaic in the eastern lunette, Mausoleum
of Galla Placidia, Ravenna, Italy. c. 425–26 (see
fig. 7-17) *(page 265)*

**7-19. Clerestory and dome, Baptistry of
the Orthodox, Ravenna,** Italy. Early 5th century;
dome remodeled c. 450–60. *(page 266)*

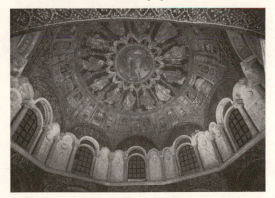

SCULPTURE

7-20. *Resurrection and Angel with Two Marys at the Tomb,* panel of a diptych, found in Rome. c. 400. *(page 267)*

7-21. *Sarcophagus of Junius Bassus.* c. 359. *(page 267)*

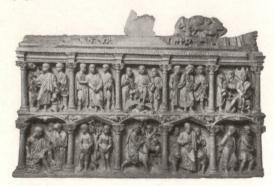

EARLY BYZANTINE ART

THE CHURCH AND ITS DECORATION

7-22. Anthemius of Tralles and Isidorus of Miletus. Church of Hagia Sophia, Istanbul, Turkey. 532–37. *(page 270)*

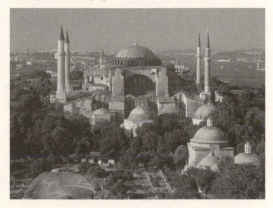

7-23. Plan and section of the Church of Hagia Sophia. *(page 271)*

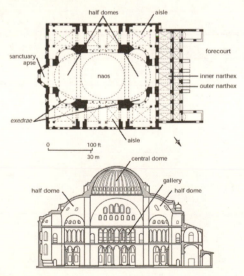

Elements of Architecture:
Pendentives and Squinches

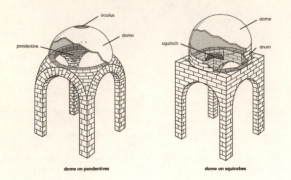

7-24. Church of Hagia Sophia. *(page 273)*

7-25. *Transfiguration of Christ,* mosaic in the apse, Church of the Virgin, Monastery of Saint Catherine, Mount Sinai, Egypt. c. 549–64. *(page 274)*

7-26. Plan and cutaway drawing of the Church of San Vitale, Ravenna, Italy. Under construction from c. 520; mosaics, c. 546–48. *(page 275)*

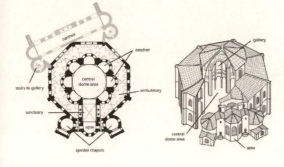

7-27. Church of San Vitale, Ravenna, Italy. Interior view across the central space toward the sanctuary apse with mosaic showing Christ enthroned and flanked by Saint Vitalis and Bishop Ecclesius. Mosaics, c. 546–48 *(page 276)*

7-28. Church of San Vitale, south wall of the sanctuary, with Abel and Melchizedek in the lunette, Moses and Isaiah in the spandrels, portraits of the evangelists in the gallery zone, and the Lamb of God in the vault. 526–547. *(page 277)*

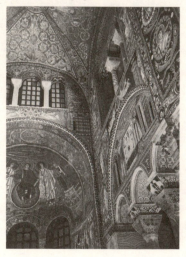

7-29. *Emperor Justinian and His Attendants*,
mosaic on north wall of the apse, Church of San
Vitale, Ravenna, Italy. c. 547. *(page 278)*

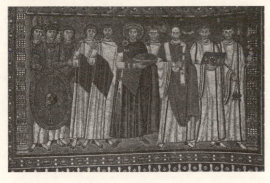

7-30. *Empress Theodora and Her Attendants*,
mosaic on south wall of the apse, Church of San Vitale.
c. 547. *(page 279)*

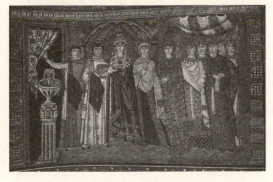

7-31. Church of Sant'Apollinare in Classe (Classis),
the former port of Ravenna, Italy. Dedicated 549. *(page 279)*

7-32. *The Transfiguration of Christ with Saint Apollinaris, First Bishop of Ravenna,* mosaic in the apse, Church of Sant' Apollinare in Classe. Apse, 6th century; mosaics above apse, 7th and 9th centuries; side panels, 7th century. Consecrated 550. *(page 280)*

7-33. *Archangel Michael,* panel of a diptych, probably from the court workshop at Constantinople. Early 6th century. *(page 281)*

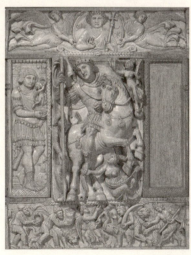

7-34. Page with *Wild Blackberry*, from *De Materia Medica*, by Pedanius Dioscorides (1st century), copy made and illustrated in Constantinople for Princess Anicia Juliana. c. 512. *(page 281)*

7-35. Page with *Rebecca at the Well*, from *Book of Genesis*, probably made in Syria or Palestine. Early 6th century. *(page 282)*

7-36. Page with *The Crucifixion*, from the
Rabbula Gospels, from Beth Zagba, Syria. 586.
(page 228)

7-37. Page with *The Ascension*, from the
Rabbula Gospels. (page 283)

MIDDLE BYZANTINE ART

ARCHITECTURE AND ITS DECORATION

Iconoclasm

7-38. *Virgin and Child with Saints and Angels,* icon. Second half of 6th century. *(page 285)*

Elements of Architecture: Multiple-Dome Church Plans

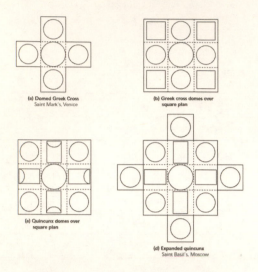

(a) Domed Greek Cross
Saint Mark's, Venice

(b) Greek cross domes over square plan

(c) Quincunx domes over square plan

(d) Expanded quincunx
Saint Basil's, Moscow

7-39. Cathedral of Saint Mark, Venice.
Present building begun 1063. *(page 287)*

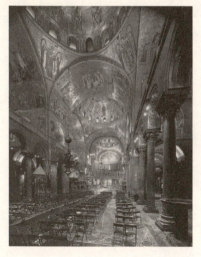

7-40. Cathedral of Santa Sophia, Kiev,
Ukraine. c. 1017–37 *(page 288)*

7-41. Interior, Cathedral of Santa Sophia. *(page 289)*

7-42. *Virgin of Vladimir,* icon, probably from Constantinople. Faces only, 12th century; the rest has been retouched. *(page 290)*

7-43. Central dome and apse, Katholikon, Monastery of Hosios Loukas, near Stiris, Greece. Early 11th century and later. *(page 291)*

7-44. *Christ Pantokrator,* mosaic in the central
dome, church of the Dormition, Daphni, Greece.
Central dome, c. 1080–1100. *(page 292)*

7-45. *Crucifixion,* mosaic in the north arm of
the east wall, Church of the Dormition, Daphni,
Greece. Late 11th century. *(page 293)*

7-46. Palatine Chapel, Palermo, Sicily. Mid-
12th century. View toward the east. *(page 294)*

7-47. Chamber of King Roger, Norman Palace,
Palermo, Sicily. Mid-12th century. *(page 295)*

IVORIES AND METALWORK

7-48. *Harbaville Triptych.* Mid-11th century.
(page 295)

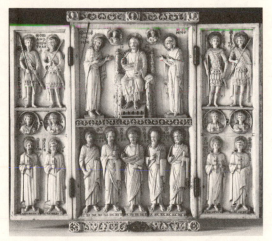

The Object Speaks:
The Archangel Michael

7-49. *Archangel Michael*, **icon.** Late 10th or
early 11th century. *(page 296)*

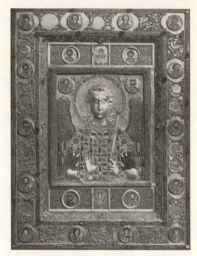

MANUSCRIPTS

7-50. Page with *David the Psalmist*, from
the *Paris Psalter*. Second half of the 10th century.
(page 297)

7-51. Page with *Joshua Leading the Israelites*,
from the *Joshua Roll*, made in Constantinople. c. 950.
(page 298)

LATE BYZANTINE ART

**7-52. Funerary chapel, Church of the Monastery
of Christ in Chora**, Constantanople (now Kariye
Mazei, Istanbul, Turkey). c. 1310–21.*(page 299)*

7-53. *Anastasis,* painting in the apse of the funerary chapel, Church of the Monastery of Christ in Chora. Getty Research Library, Los Angeles, Wim Swaan Photograph Collection, 96.P.21. *(page 300)*

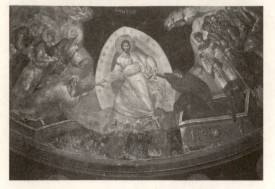

7-54. Barma and Postnik. Cathedral of Saint Basil the Blessed, Moscow. 1555–61.*(page 300)*

7-55. Andrey Rublyov. *The Old Testament Trinity (Three Angels Visiting Abraham),* **icon.** c. 1410–20. *(page 301)*

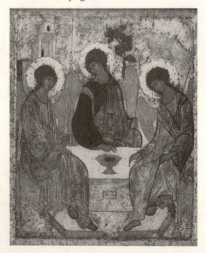

8

ISLAMIC ART

Notes

8-1. Page from Koran (*Surah* II: 286 and title *Surah* III) in kufic script, from Syria. 9th century. *(page 304)*

ISLAM AND EARLY ISLAMIC SOCIETY

Map 8-1. The Islamic World. Within 200 years of its founding in 610 CE, the Islamic world expanded from Mecca to India in the east, to Spain in the northwest, and to Africa in the south. *(page 304)*

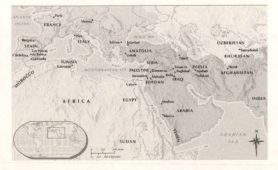

ART DURING THE EARLY CALIPHATES

ARCHITECTURE

8-2. Dome of the Rock, Jerusalem. Begun 692. *(page 306)*

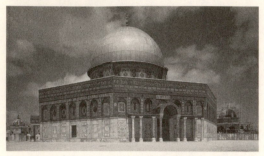

8-3. Cutaway drawing of the Dome of the Rock. *(page 306)*

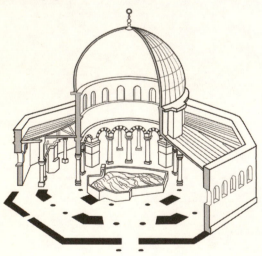

8-4. Dome of the Rock, Jerusalem. Interior.
(page 306)

Islam and the Prophet Muhammad

The Prophet Muhammad and His Companions Traveling to the Fair, from a copy of the 14th-century *Siyar-i Nabi (Life of the Prophet)* of al-Zarir, Istanbul, Turkey. 1694. *(page 307)*

8-5. Plan of the palace, Mshatta, Jordan.
Begun 740s. *(page 308)*

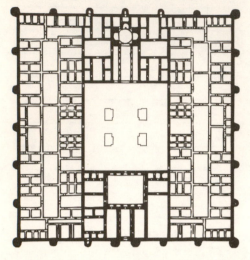

8-6. Frieze, detail of facade, palace, Mshatta.
(page 308)

8-7. The Great Mosque, Kairouan, Tunisia.
836–75. *(page 309)*

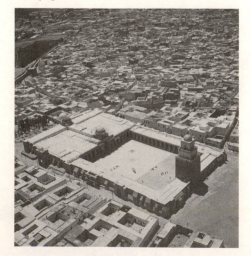

8-8. Prayer hall, Great Mosque, Córdoba,
Spain. Begun 785–86, extension of 987. *(page 310)*

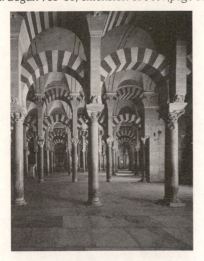

**8-9. Dome in front of the *mihrab*, Great
Mosque.** 965. *(page 310)*

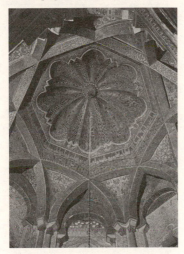

Elements of Architecture:
Mosque Plans

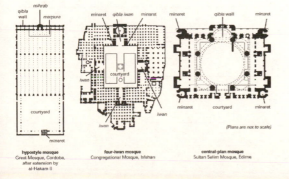

hypostyle mosque
Great Mosque, Córdoba,
after extension by
al-Hakam II

four-iwan mosque
Congregational Mosque, Isfahan

central-plan mosque
Sultan Selim Mosque, Edirne

Elements of Architecture:
Arches and *Muqarnas*

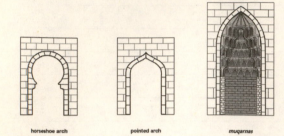

horseshoe arch pointed arch *muqarnas*

CALLIGRAPHY

CERAMICS AND TEXTILES

8-10. Bowl with kufic border, from Samarkand,
Uzbekistan. 9th–10th century. *(page 312)*

8-11. Textile with elephants and camels,
known today as the Shroud of Saint Josse, from
Khurasan or Central Asia. Before 961. *(page 313)*

LATER ISLAMIC ART

ARCHITECTURE

**8-12. Courtyard, Congregational Mosque,
Isfahan,** Persia (Iran). 11th–18th century. *Iwan* vault,
14th century, minarets, 17th century. *(page 314)*

8-13. Tile mosaic *mihrab*, from the Madrasa Imami, Isfahan, Persia (Iran). *(page 315)*

8-14. *Qibla* wall with *mihrab* and *minbar*, main *iwan* (vaulted chamber) in the mosque, Sultan Hasan *madrasa*-mausoleum-mosque complex, Cairo, Egypt. 1356–63. *(page 315)*

8-15. Court of the Lions, Palace of the Lions, Alhambra, Granada, Spain. 1354–91. *(page 316)*

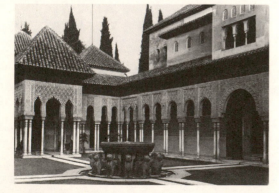

8-16. *Muqarnas* **dome (plaster ceiling), Hall of the Abencerrajes, Palace of the Lions, Alhambra.** 1354–91. *(page 317)*

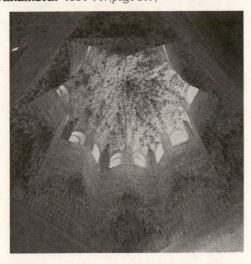

PORTABLE ARTS

8-17. Griffin, from the Islamic Mediterranean, probably Fatimid Egypt. 11th century. *(page 318)*

8-18. Shazi. Pen box, from Persia (Iran) or
Afghanistan. 1210–11. *(page 318)*

8-19. Bottle, from Syria. Mid-14th century.
(page 319)

8-20. *The Macy Jug,* from Iran. 1215–16.
(page 319)

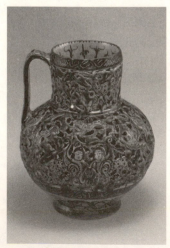

8-21. Banner of Las Navas de Tolosa, detail of
center panel, from southern Spain. 1212–50. *(page 320)*

Technique: Carpet Making

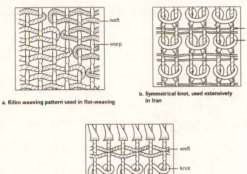

a. Kilim weaving pattern used in flat-weaving

b. Symmetrical knot, used extensively
in Iran

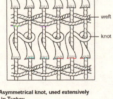

c. Asymmetrical knot, used extensively
in Turkey

8-22. Medallion rug, variant Star Ushak style,
Anatolia (modern Turkey). 16th century. *(page 322)*

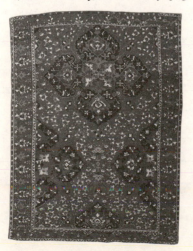

MANUSCRIPT ILLUMINATION
AND CALLIGRAPHY

8-23. Koran frontispiece (right half of two-page spread), from Cairo, Egypt. c. 1368. *(page 322)*

8-24. Bahrum Gur and the Indian Princess in Her Black Pavillion, a copy of the 12th-century *Seven Portraits (Haft Paykar)* of Nizami, Herat, Afghanistan. Timurid Period, c. 1426. *(page 324)*

8-25. Kamal al-Din Bihzad. *The Caliph Harun al-Rashid Visits the Turkish Bath,* from a copy of the 12th-century *Khamsa (Five Poems)* of Nizami, Herat, Afghanistan c. 1494. *(page 325)*

THE OTTOMAN EMPIRE

ARCHITECTURE

8-26. Sinan. Mosque of Sultan Selim, Edirne, Turkey. 1568–75. *(page 326)*

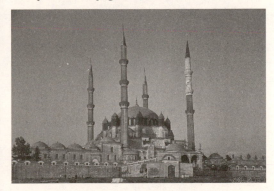

8-27. Interior, Mosque of Sultan Selim.
(page 326)

ILLUMINATED MANUSCRIPTS AND *TUGRAS*

8-28. Illuminated *tugra* of Sultan Suleyman, from Istanbul, Turkey. c. 1555–60.
(page 327)

9

ART OF INDIA
BEFORE 1200

Notes

9-1. Ashokan pillar, Lauriya, Nandangarh.
Maurya period. 246 BCE. *(page 328)*

THE INDIAN SUBCONTINENT

**Map 9-1. The Indian Subcontinent before
1200.** The Vindhya Hills are a natural feature
dividing North and South India. *(page 330)*

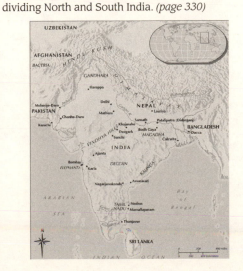

INDUS VALLEY CIVILIZATION

9-2. Seal impressions: a., d. horned animal;
b. buffalo; c. sacrificial rite to a goddess (?); e. yogi;
f. three-headed animal. Indus Valley civilization,
c. 2500–1500 BCE. *(page 331)*

INDUS VALLEY CIVILIZATION

**9-3. Large water tank, possibly a public or
ritual bathing area, Mohenjo-Daro**. Indus Valley
civilization, Harappan. c. 2600–1900 BCE. *(page 332)*

Notes

9-4. Torso of a "priest-king," from Mohenjo-Daro.
Indus Valley civilization, c. 2000–1900 BCE. *(page 333)*

9-5. Torso, from Harappa. Indus Valley
civilization, c. 2000 BCE. *(page 333)*

**9-6. *Large Painted Jar with Border Containing
Birds,*** from Chanhu-Daro. Indus Valley civilization,
c. 2400–2000 BCE. *(page 333)*

Buddhism

THE VEDIC PERIOD

THE MAURYA PERIOD

9-7. *Yakshi Holding a Fly Whisk,* from
Didarganj, Patna, Bihar, India. Maurya period, c. 250 BCE.
(page 335)

Hinduism

9-8. Lion capital, from an Ashokan pillar at Sarnath, Uttar Pradesh, India. Maurya period, c. 250 BCE. *(page 337)*

THE PERIOD OF THE SHUNGAS
AND EARLY ANDHRAS

STUPAS

9-9. Great Stupa, Sanchi, Madhya Pradesh, India.
Founded 3rd century BCE, enlarged c. 150–50 BCE.
(page 338)

**9-10. East *torana* of the Great Stupa at
Sanchi.** Early Andhra period, mid-1st century BCE.
(page 338)

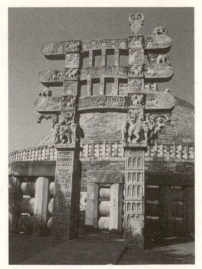

9-11. *Yakshi* **bracket figure,** on the east
torana of the Great Stupa at Sanchi. *(page 339)*

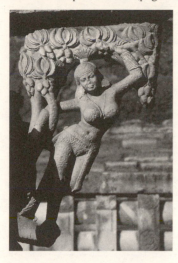

BUDDHIST ROCK-CUT HALLS

9-12. Section of the *chaitya* **hall at Karla,**
Maharashtra, India. Early Andhra period, second
half of 1st century BCE. *(page 339)*

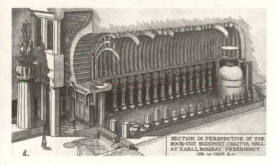

9-13. *Chaitya* hall at Karla. *(page 339)*

Elements of Architecture:
Stupas and Temples

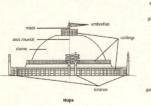

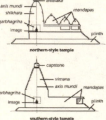

THE KUSHAN AND LATER ANDHRA PERIODS

THE GANDHARA SCHOOL

9-14. *Standing Buddha,* from Gandhara (Pakistan). Kushan period, c. 2nd–3rd century CE. *(page 341)*

THE MATHURA SCHOOL

9-15. *Buddha and Attendants,* from Katra Keshavdev, Mathura, Madhya Pradesh, India. Kushan period, c. late 1st–early 2nd century CE. *(page 342)*

THE AMARAVATI SCHOOL

9-16. *Siddhartha in the Palace,* detail of a
relief from Nagarjunakonda, Andhra Pradesh, India.
Later Andhra period, c. 3rd century CE. *(page 343)*

Mudras

THE GUPTA PERIOD

BUDDHIST SCULPTURE

9-17. *Standing Buddha,* from Sarnath, Uttar Pradesh, India. Gupta period, 474 CE. *(page 344)*

PAINTING

9-18. *Bodhisattva,* detail of a wall painting in Cave I, Ajanta, Maharashtra, India. Gupta period, c. 475 CE. *(page 345)*

THE POST-GUPTA PERIOD

THE EARLY NORTHERN TEMPLE

**Meaning and Ritual in Hindu
Temples and Images**

9-19. Vishnu Temple at Deogarh, Uttar
Pradesh, India. Post-Gupta period, c. 530 CE.
(page 347)

**9-20. Doorway of the Vishnu Temple at
Deogarh.** *(page 348)*

**9-21. *Vishnu Narayana on the Cosmic
Waters,*** relief panel in the Vishnu Temple at
Deogarh. Stone c. 530 CE. *(page 348)*

MONUMENTAL NARRATIVE RELIEFS

9-22. Cave-Temple of Shiva at Elephanta,
Maharashtra, India. Post-Gupta period, mid-6th
century CE. *(page 349)*

9-23. *Eternal Shiva,* rock-cut relief in the Cave-
Temple of Shiva at Elephanta. Mid-6th century CE.
(page 350)

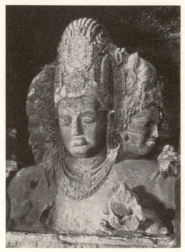

9-24. *Durga Mahishasura-mardini (Durga as Slayer of the Buffalo Demon),* rock-cut relief, Mamallapuram, Tamil Nadu, India. Pallava period, c. mid-7th century CE. *(page 351)*

THE EARLY SOUTHERN TEMPLE

9-25. Dharmaraja Ratha, Mamallapuram, Tamil Nadu, India. Pallava period, c. mid-7th century CE. *(page 352)*

THE EARLY MEDIEVAL PERIOD

THE MONUMENTAL NORTHERN TEMPLE

9-26. Kandariya Mahadeva temple, Khajuraho, Madhya Pradesh, India. Chandella dynasty, Early Medieval period, c. 1000 CE. *(page 353)*

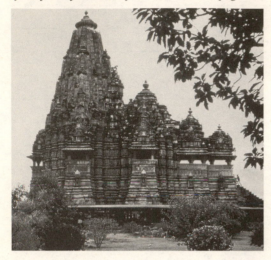

THE MONUMENTAL SOUTHERN TEMPLE

9-27. Rajarajeshvara Temple to Shiva, Thanjavur, Tamil Nadu, India. Chola dynasty, Early Medieval period, 1003–10 CE. *(page 354)*

THE BHAKTI MOVEMENT IN ART

9-28. *Rajaraja I and His Teacher*, detail of a
wall painting in the Rajarajeshvara Temple to Shiva.
Chola dynasty, Early Medieval period, c. 1010 CE.
(page 355)

9-29. *Shiva Nataraja*, from Thanjavur, Tamil
Nadu. Chola dynasty, 12th century CE. *(page 356)*

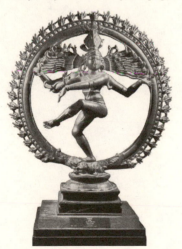

10

CHINESE ART
BEFORE 1280

10-1. Soldiers, from the mausoleum of Emperor Shihuangdi, Lintong, Shaanxi. Qin dynasty, c. 210 BCE. *(page 358)*

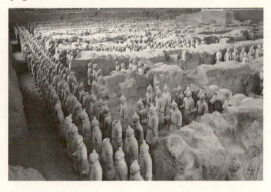

THE MIDDLE KINGDOM

Map 10-1. China before 1280. The heart of China is crossed by three great rivers—the Yellow, Yangzi, and Xi—and is divided into northern and southern regions by the Qinling Mountains. *(page 360)*

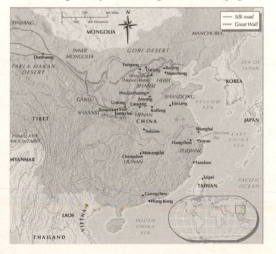

NEOLITHIC CULTURES

PAINTED POTTERY CULTURES

10-2. Bowl, from Banpo, near Xi'an, Shaanxi. Neolithic period, Yangshao culture, 5000–4000 BCE. *(page 361)*

LIANGZHU CULTURE

10-3. Image of a deity, detail from a *cong* (see fig. 10–4 for schematic of a complete *cong*) recovered from Tomb 12, Fanshan, Yuyao, Zhejiang. Neolithic period, Liangzhu culture, before 3000 BCE. *(page 361)*

10-4. Schematic drawing of a *cong*.
(page 361)

BRONZE AGE CHINA

SHANG DYNASTY

Technique:
Piece-Mold Casting

10-5. *Fang ding,* from Tomb 1004, Houjiazhuang, Anyang, Henan. Shang dynasty, Anyang period, c. 12th century BCE. *(page 363)*

Chinese Characters

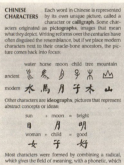

CHINESE CHARACTERS Each word in Chinese is represented by its own unique picture, called a character or calligraph. Some characters originated as **pictographs**, images that mean what they depict. Writing reforms over the centuries have often disguised the resemblance, but if we place modern characters next to their oracle-bone ancestors, the picture comes back into focus:

	water	horse	moon	child	tree	mountain
ancient						
modern	水	馬	月	子	木	山

Other characters are **ideographs**, pictures that represent abstract concepts or ideas:

sun	+ moon	= bright
日	月	明

woman	+ child	= good
女	子	好

Most characters were formed by combining a radical, which gives the field of meaning, with a phonetic, which originally hinted at pronunciation. For example, words that have to do with water have the character for "water" 水 abbreviated to three strokes 氵 as their radical. Thus "to bathe" 沐, pronounced *mu*, consists of the water radical and the phonetic 木, which by itself means "tree" and is also pronounced *mu*. Here are other "water" characters. Notice that the connection to water is not always literal.

river	sea	weep	pure, clear	extinguish, destroy
河	海	泣	清	滅

These phonetic borrowings took place centuries ago. Many words have shifted in pronunciation, and for this and other reasons there is no way to tell how a character is pronounced or what it means just by looking at it. While at first this may seem like a disadvantage, in the case of Chinese it is actually a strength. Spoken Chinese has many dialects. Some are so far apart in sound as to be virtually different languages. But while speakers of different dialects cannot understand each other, they can still communicate through writing, for no matter how they say a word, they write it with the same character. Writing has thus played an important role in maintaining the unity of Chinese civilization through the centuries.

ZHOU DYNASTY

10-6. Set of sixty-five bells, from the tomb of
Marquis Yi of Zeng, Suixian, Hubei. Zhou dynasty,
433 BCE. *(page 364)*

THE CHINESE EMPIRE:
QIN DYNASTY

HAN DYNASTY

10-7. Painted banner, from the tomb of the wife
of the Marquis of Dai, Mawangdui, Changsha, Hunan.
Han dynasty, c. 160 BCE. *(page 365)*

**The Silk Road
and the Making of Silk**

Daoism

PHILOSOPHY AND ART

10-8. Incense burner, from the tomb of Prince
Liu Sheng, Mancheng, Hebei. Han dynasty, 113 BCE.
(page 367)

Confucius and Confucianism

10-9. Detail from a rubbing of a stone relief in the Wu family shrine (Wuliangci), Jiaxiang, Shandong. Han dynasty, 151 CE, *(page 369)*

ARCHITECTURE

10-10. Tomb model of a house. Eastern Han dynasty, 1st–mid 2nd century CE. *(page 339)*

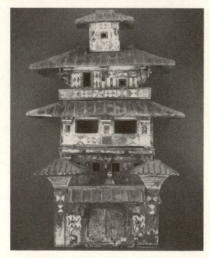

SIX DYNASTIES

PAINTING

10-11. Attributed to Gu Kaizhi. Detail of
Admonitions of the Imperial Instructress to Court
Ladies. Six Dynasties period, c. 344–406 CE. *(page 370)*

CALLIGRAPHY

10-12. Wang Xizhi. Portion of a letter from
the *Feng Ju* album. Six Dynasties period, mid-
4th century CE. *(page 371)*

BUDDHIST ART AND ARCHITECTURE

10-13. Seated Buddha, Cave 20, Yungang, Datong, Shanxi. Northern Wei dynasty, c. 460 CE. *(page 372)*

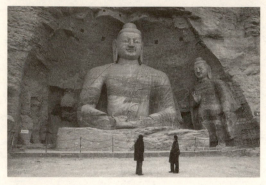

SUI AND TANG DYNASTIES

10-14. Altar to Amitabha Buddha. Sui dynasty, 593 CE. *(page 372)*

10-15. *Camel Carrying a Group of Musicians,* from a tomb near Xi'an, Shanxi. Tang dynasty, c. mid-8th century CE. *(page 373)*

BUDDHIST ART AND ARCHITECTURE

10-16. *The Western Paradise of Amitabha Buddha,* detail of a wall painting in Cave 217, Dunhuang, Gansu. Tang dynasty, c. 750 CE. *(page 374)*

10-17. Nanchan Temple, Wutaishan, Shanxi.
Tang dynasty, 782 CE. *(page 375)*

**10-18. Great Wild Goose Pagoda at Ci'en
Temple, Xi'an,** Shanxi. Tang dynasty, first erected
645 CE; rebuilt mid-8th century CE. *(page 375)*

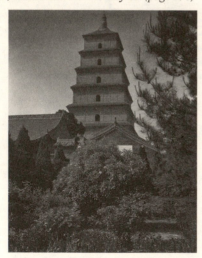

FIGURE PAINTING

10-19. Attributed to Emperor Huizong. Detail of *Ladies Preparing Newly Woven Silk*, copy after a lost Tang dynasty painting by Zhang Xuan. Northern Song dynasty, early 12th century CE. *(page 376)*

SONG DYNASTY

10-20. *Seated Guanyin Bodhisattva.* Liao dynasty, 10th-12th century. *(page 376)*

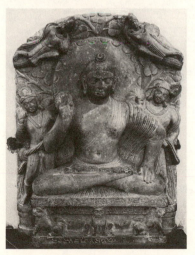

Elements of Architecture: Pagodas

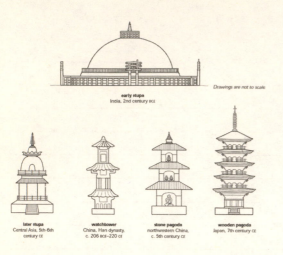

early stupa
India, 2nd century BCE

Drawings are not to scale

later stupa
Central Asia, 5th-6th
century CE

watchtower
China, Han dynasty,
c. 206 BCE–220 CE

stone pagoda
northwestern China,
c. 5th century CE

wooden pagoda
Japan, 7th century CE

PHILOSOPHY: NEO-CONFUCIANISM

NORTHERN SONG PAINTING

10-21. Fan Kuan. *Travelers among Mountains and Streams.* Northern Song dynasty, early 11th century CE. *(page 379)*

10-22. Xu Daoning. Detail of *Fishing in a Mountain Stream*. Northern Song dynasty, mid-11th century CE. *(page 379)*

10-23. Zhang Zeduan. Detail of *Spring Festival on the River*. Northern Song dynasty, early 12th century CE. *(page 380)*

SOUTHERN SONG PAINTING AND CERAMICS

10-24. Xia Gui. Detail of *Twelve Views from a Thatched Hut*. Southern Song dynasty, early 13th century CE. *(page 380)*

10-25. Guan ware vase. Southern Song dynasty, 13th century CE. *(page 382)*

11

JAPANESE ART
BEFORE 1392

11-1. Kosho. *Kuya Preaching*. Kamakura period, before 1207. *(page 384)*

Notes

PREHISTORIC JAPAN

Map 11-1. Japan before 1392. Melting glaciers at the end of the Ice Age in Japan 15,000 years ago raised the sea level and formed the four main islands of Japan: Hokkaido, Honshu, Shikoku, and Kyushu. *(page 386)*

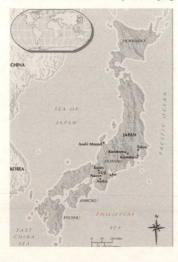

JOMON PERIOD

11-2. Vessel, from the Asahi Mound, Toyama
Prefecture. Jomon period, c. 2000 BCE. *(page 387)*

11-3. *Dogu*, from Kurokoma, Yamanashi
Prefecture. Jomon period, c. 2000 BCE. *(page 387)*

YAYOI AND KOFUN PERIODS

11-4. *Haniwa*, from Kyoto. Kofun period, 6th
century CE. *(page 388)*

ASUKA PERIOD

11-5. Inner shrine, Ise, Mie Prefecture. Yayoi
period, early 1st century CE; last rebuilt 1993. *(page 389)*

11-6. Main compound, Horyu-ji, Nara
Prefecture. Asuka period, 7th century CE. *(page 390)*

11-7. *Hungry Tigress Jataka*, panel of the Tamamushi
Shrine, Horyu-ji. Asuka period, c. 650 CE. *(page 391)*

11-8. Tori Busshi. *Shaka Triad*, in the *kondo*,
Horyu-ji. Asuka period, c. 623 CE. *(page 391)*

NARA PERIOD

Buddhist Symbols

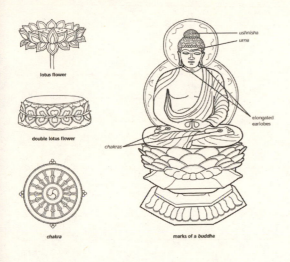

lotus flower

double lotus flower

chakra

ushnisha
urna
elongated earlobes
chakras
marks of a *buddha*

11-9. *Amida Buddha,* fresco in the *kondo,*
Horyu-ji. Nara period, c. 700 CE. *(page 393)*

HEIAN PERIOD

ESOTERIC BUDDHIST ART

11-10. Womb World *mandala*, To-ji, Kyoto.
Heian period, late 9th century CE. *(page 394)*

PURE LAND BUDDHIST ART

11-11. Byodo-in, Uji, Kyoto Prefecture. Heian
period, c. 1053 CE. *(page 395)*

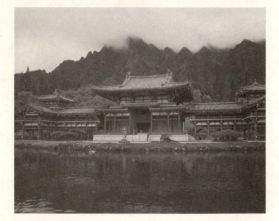

11-12. Jocho. *Amida Buddha,* Byodo-in. Heian
period, c. 1053 CE. *(page 396)*

**Technique: Joined-Wood
Sculpture**

POETRY AND CALLIGRAPHY

11-13. Album leaf from the *Ishiyama-gire*.
Heian period, early 12th century CE. *(page 397)*

SECULAR PAINTING

Writing, Language, and Culture

色は匂へど
散りぬるを
我世誰ぞ
常ならむ

いろはにほへと
ちりぬるを
わかよたれそ
つねならむ

イ ロ ハ ニ ホ ヘ ト
チ リ ヌ ル ヲ
ワ カ ヨ タ レ ソ
ツ ネ ナ ラ ム

kanji and kana *hiragana* *katakana*

11-14. Scene from *The Tale of Genji*. Heian
period, 12th century CE. *(page 399)*

**11-15. Attributed to Toba Sojo. Detail of
Frolicking Animals.** Heian period, 12th century CE.
(page 399)

KAMAKURA PERIOD

11-16. **Detail of** *Night Attack on the Sanjo Palace.* Kamakura period, late 13th century CE. *(page 400)*

11-17. Enlarged detail of the left side of *Night Attack on the Sanjo Palace.* (Fig. 11–16). *(page 400)*

PURE LAND BUDDHIST ART

Arms and Armor

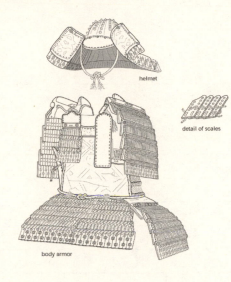

helmet

detail of scales

body armor

11-18. *Descent of the Amida Trinity,* *raigo* triptych. Kamakura period, late 13th century CE. *(page 402)*

ZEN BUDDHIST ART

The Object Speaks:
Monk Sewing

11-19. Attributed to Kao Ninga. *Monk Sewing.* Kamakura period, early 14th century. *(page 403)*

ZEN BUDDHIST ART

12

ART OF THE AMERICAS BEFORE 1300

Notes

12-1. Pueblo Bonito, Chaco Canyon, New Mexico. Anasazi culture, c. 900–1230 CE. *(page 404)*

THE NEW WORLD

Map 12-1. The Americas. Between 15,000 and 17,000 years ago, Paleo-Indians moved across North America, then southward through Central America until they reached the Tierra del Fuego region of South America about 12,500 years ago. *(page 406)*

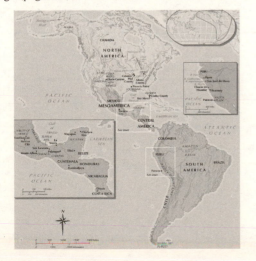

MESOAMERICA

THE OLMEC

12-2. Great Pyramid and ball court, La Venta, Mexico. Olmec culture, c. 900–600 BCE. *(page 408)*

The Cosmic Ball Game

12-3. Colossal head (no. 4), from La Venta,
Mexico. Olmec culture, c. 900 BCE. *(page 409)*

TEOTIHUACAN

**12-4. Ceremonial center of the city of
Teotihuacan,** Mexico. Teotihuacan culture, c. 500 CE.
(page 410)

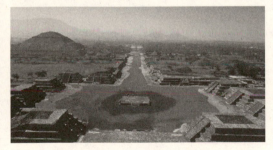

12-5. Plan of the ceremonial center of Teotihuacan. *(page 410)*

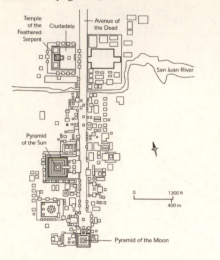

12-6. Temple of the Feathered Serpent, the Ciudadela, Teotihuacan, Mexico. Teotihuacan culture, after 250 CE. *(page 411)*

12-7. *Maguey Bloodletting Ritual*, fragment of a fresco from Teotihuacan, Mexico. Teotihuacan culture, 600–750 CE. *(page 412)*

THE MAYA

12-8. Base of North Acropolis (left) and Temple I, called the Temple of the Giant Jaguar (tomb of Ah Hasaw), Tikal, Guatemala. Maya culture. North Acropolis, 5th century CE; Temple I, c. 700 CE. *(page 413)*

Maya Record Keeping

12-9. "Palace" (foreground) and Temple of the Inscriptions (tomb-pyramid of Lord Pacal), Palenque, Mexico. Maya culture, 600–900 CE. *(page 414)*

12-10. Sarcophagus lid, in the tomb of Lord Pacal (Shield 2), Temple of the Inscriptions, Palenque, Mexico. Maya culture, c. 683 CE. *(page 415)*

12-11. Portrait of Lord Pacal, from his tomb, Temple of the Inscriptions, Palenque, Mexico. Maya culture, mid-7th century CE. *(page 415)*

12-12. Cylindrical vessel (composite photograph in the form of a roll-out). Maya culture, 600–900 CE. *(page 416)*

12-13. Pyramid ("el Castillo") with Chacmool in foreground, Chichen Itza, Yucatan, Mexico. Itza (northern Maya) culture, 9th–13th century CE; Chacmool, 800–1000 CE *(page 416)*

CENTRAL AMERICA

12-14. Shaman with Drum and Snake, from
Costa Rica. Diquis culture, c. 13th–16th century CE.
(page 417)

SOUTH AMERICA:
THE CENTRAL ANDES

THE PARACAS AND NAZCA CULTURES

12-15. Mantle with bird impersonators,
from the Paracas peninsula, Peru. Paracas culture,
c. 50–100 CE. *(page 418)*

Technique: Andean Textiles

Detail of tapestry-weave mantle, from Peru.
c. 700–1100 CE. Wool and cotton. The Cleveland
Museum of Art. *(page 419)*

**Diagram of toothed tapestry-weaving tech-
nique,** one of many sophisticated methods used in
Andean textiles. *(page 419)*

**12-16. Earth drawing of a hummingbird,
Nazca Plain,** southwest Peru. Nazca culture,
c. 200 BCE–200 CE. *(page 420)*

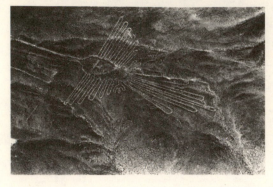

THE MOCHE CULTURE

12-17. *Moche Lord with a Feline,* from
Moche Valley, Peru. Moche culture, c. 100 BCE–500 CE.
(page 421)

12-18. Earspool, from Sipan, Peru. Moche
culture, 2d–5th century CE. *(page 421)*

NORTH AMERICA

12-19. Beaver effigy platform pipe, from
Bedford Mound, Pike County, Illinois. Hopewell
culture, c. 100–200 CE. *(page 422)*

THE MOUND BUILDERS

12-20. Great Serpent Mound, Adams County, Ohio. c. 1070 CE. *(page 422)*

12-21. Reconstruction of central Cahokia, East St. Louis, Illinois. Mississippian culture, c. 1150 CE. *(page 423)*

12-22. Cahokia. *(page 423)*

12-23. Pelican figurehead. Florida Glades
Culture, Key Marco, c. 1000 CE. *(page 424)*

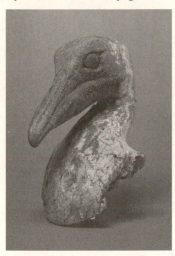

THE AMERICAN SOUTHWEST

12-24. Seed jar. Anasazi culture, c. 1150 CE.
(page 425)

13
ART OF ANCIENT AFRICA

13-1. Ritual vessel, from Ife. Yoruba, 13–14th century. *(page 426)*

Notes

THE LURE OF ANCIENT AFRICA

Map 13-1. Ancient Africa. Nearly 5,000 miles from north to south, Africa is the second-largest continent and was the home of some of the earliest and most advanced cultures of the ancient world. *(page 428)*

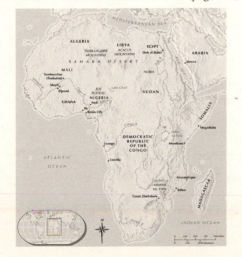

SAHARAN ROCK ART

13-2. *Cattle Being Tended,* section of rock-wall
painting, Tassili-n-Ajjer, Algeria. c. 2500–1500 BCE.
(page 430)

SUB-SAHARAN CIVILIZATIONS

NOK

13-3. Head. Nok, c. 500 BCE–200 CE. *(page 431)*

IFE

13-4. Head of a king, from Ife. Yoruba, c. 13th
century CE. *(page 432)*

**13-5. Head said to represent the
Usurper Lajuwa,** from Ife. Yoruba, c. 1200–1300
CE. *(page 432)*

BENIN

13-6. Memorial head. Benin Early Period, c. 1400–1550 CE. *(page 433)*

Who Made African Art?

13-7. Head of an *oba* (king). Benin Late
Period, c. 1700–1897 CE. *(page 434)*

13-8. *General and Officers (Warrior and Attendants).*
Benin Middle Period, c. 1550–1650 CE. *(page 435)*

**13-9. Mask representing an *iyoba* (queen
mother).** Benin Middle Period, c. 1550 CE. *(page 435)*

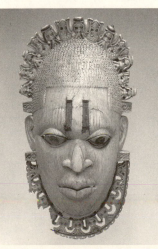

OTHER URBAN CENTERS

DJENNÉ

13-10. *Horseman*, **from Old Djenné,** Mali.
13–15th century. *(page 436)*

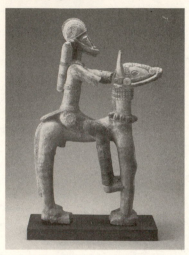

13-11. Great Friday Mosque, Djenné, Mali,
showing the eastern and northern facades.
Rebuilding of 1907, in the style of 13th-century
original. *(page 437)*

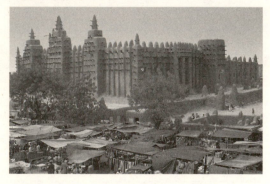

GREAT ZIMBABWE

13-12. Conical Tower, Great Zimbabwe.
c. 1200–1400 CE. *(page 438)*

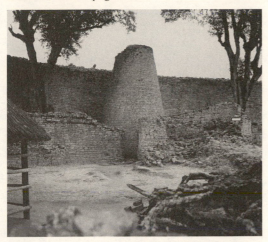

13-13. Bird, top part of a monolith, from
Great Zimbabwe. c. 1200–1400 CE. *(page 439)*

14
EARLY MEDIEVAL
ART IN EUROPE

Notes

14-1. *Chi Rho Iota page,* Book of Matthew, Chapter 1 verse 18 from the *Book of Kells*, probably made at Iona, Scotland. Late 8th or early 9th century. *(page 440)*

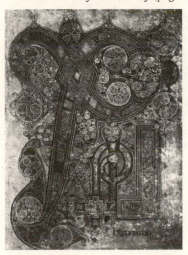

THE MIDDLE AGES

Map 14-1. Europe of the Early Middle Ages.
On this map, modern names have been used for medieval regions in northern and western Europe to make sites of art works easier to locate. *(page 442)*

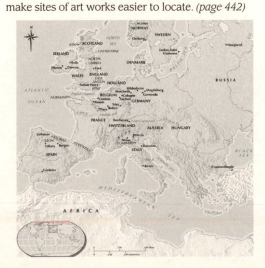

THE BRITISH ISLES
AND SCANDINAVIA

14-2. Gummersmark brooch, Denmark. 6th century. *(page 444)*

14-3. Purse cover, from the Sutton Hoo burial ship, Suffolk, England, first half of 7th century. *(page 445)*

14-4. Page with *Man*, Gospel of Saint Matthew,
Gospel Book of Durrow, probably made at Iona,
Scotland, or northern England, second half of 7th
century. *(page 446)*

14-5. Cats and Mice with Host, detail of,
fig. 14-1, *Chi Rho Iota* page, Book of Matthew,
Chapter 1 verse 18 from the *Book of Kells*, probably
made at Iona, Scotland. Late 8th or early 9th
century. *(page 447)*

The Medieval *Scriptorium*

14-6. South Cross, Ahenny, County Tipperary, Ireland. 8th century. *(page 447)*

CHRISTIAN SPAIN

14-7. Church of Santa Maria de Quintanilla de las Viñas, Burgos, Spain. Late 7th century. *(page 448)*

14-8. Emeterius and Senior. Colophon page, *Commentary on the Apocalypse* **by Beatus and** *Commentary on Daniel* **by Jerome,** made for the Monastery of San Salvador at Tábara, León, Spain. Completed July 27, 970. *(page 449)*

14-9. Emeterius and Ende, with the scribe Senior. Page with *Battle of the Bird and the Serpent,* *Commentary on the Apocalypse* by Beatus and *Commentary on Daniel* by Jerome, made for Abbot Dominicus, probably at the Monastery of San Salvador at Tábara, León, Spain. Completed July 6, 975. *(page 449)*

LANGOBARD ITALY

14-10. Cross, from the Church of Saint Giulia, Brescia, Italy. Late 7th–early 9th century. *(page 450)*

CAROLINGIAN EUROPE

ARCHITECTURE

**14-11. Abbey Church of Saint Riquier,
Monastery of Centula,** France, dedicated 799.
Engraving dated 1612, after an 11th-century
drawing. *(page 452)*

**14-12. Reconstruction drawing of the
Palace Chapel of Charlemagne, Aachen
(Aix-la-Chapelle),** Germany. 792–805. *(page 452)*

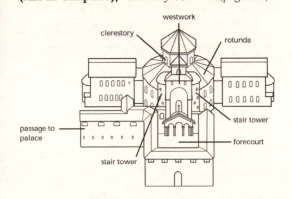

14-13. Palace Chapel of Charlemagne
Interior view, Aochen (Aix-la-Chapelle), Germany.
792–805. *(page 453)*

14-14. Plan of the Abbey of Saint Gall
(redrawn). c. 817. *(page 454)*

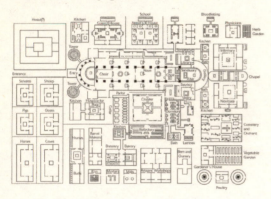

14-15. Model after the Saint Gall
monastery plan (see fig. 14-14), constructed by
Walter Horn and Ernst Born, 1965. *(page 454)*

BOOKS

14-16. Page with *Mark the Evangelist*,
Book of Mark, *Godescalc Evangelistary*. 781–83.
(page 455)

14-17. Page with *Matthew the Evangelist*,
Book of Matthew, *Ebbo Gospels*. Second quarter of
9th century. *(page 456)*

14-18. Page with *Psalm 23*, *Utrecht Psalter.*
Second quarter of 9th century. *(page 456)*

**14-19. *Crucifixion with Angels and
Mourning Figures*,** outer cover, *Lindau Gospels.*
c. 870–80. *(page 457)*

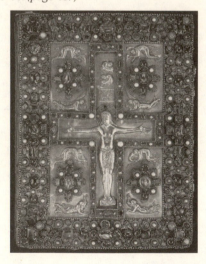

SCANDINAVIA:
THE VIKINGS

14-20. Memorial stone, Larbro Saint Hammers, Gotland, Sweden. 8th century. *(page 455)*

14-21. Burial ship, from Oseberg, Norway. Ship c. 815–20; burial 834. *(page 456)*

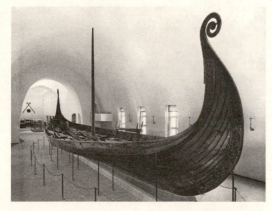

14-22. Post, from the Oseberg burial ship (see fig. 14-22). c. 815–20. *(page 457)*

OTTONIAN EUROPE

ARCHITECTURE

14-23. Church of Saint Cyriakus, Gernrode, Germany. Begun 961; consecrated 973. *(page 461)*

14-24. Plan of the Church of Saint Cyriakus
(after Broadley). *(page 461)*

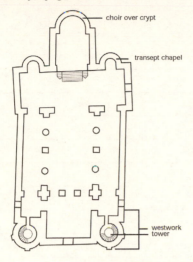

choir over crypt

transept chapel

westwork tower

14-25. Nave, Church of Saint Cyriakus.
(page 462)

SCULPTURE

14-26. *Otto I Presenting Magdeburg Cathedral to Christ*, one of a series of 17 ivory plaques known as the *Magdeburg Ivories*, possibly carved in Milan c. 962–68. *(page 462)*

14-27. **Gero Crucifix**, from Cologne Cathedral, Germany. c. 970. *(page 463)*

The Object Speaks:
The Doors of Bishop Bernward

14-28. Doors of Bishop Bernward, made for
the Abbey Church of Saint Michael, Hildesheim,
Germany. 1015. *(page 464)*

14-29. Schematic diagram of the message of the Doors of Bishop Bernward (page 465)

BOOKS

14-30. Page with *Otto III Enthroned*, *Liuthar Gospels (Aachen Gospels)*. c. 996. (page 466)

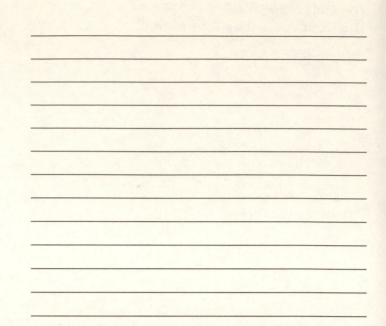

14-31. Page with *Christ Washing the Feet of His Disciples,* *Aachen Gospels of Otto III.* c. 1000. *(page 467)*

14-32. Presentation page with *Abbess Hitda and Saint Walpurga,* *Hitda Gospels.* Early 11th century. *(page 468)*

15
ROMANESQUE ART

15-1. Reliquary statue of Saint Foy (Saint Faith),
made in the Auvergne region, France, for the Abbey
Church of Conques, Conques, Midi-Pyrénées, France. Late
9th century with later additions. *(page 470)*

ROMANESQUE CULTURE

Map 15-1. Europe in the Romanesque Period.
The term *Romanesque* is now applied to all the arts in
Europe between the mid-eleventh and late-twelfth
centuries. *(page 472)*

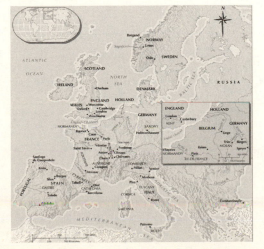

FRANCE
AND NORTHERN SPAIN

ARCHITECTURE

15-2. Reconstruction drawing of the Cathedral of Saint James, Santiago de Compostela, Spain, 1078–1122. *(page 475)*

15-3. Plan (after Conant) of Cathedral of Saint James, Santiago de Compostela. *(page 475)*

15-4. Puerta de las Platerías (Door of the Silversmiths), south transept portal of Cathedral of Saint James, Santiago de Compostela. c. 1078–1122. *(page 476)*

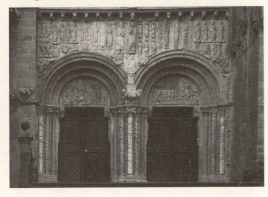

15-5. Transept, Cathedral of Saint James, Santiago de Compostela. View toward the crossing. *(page 478)*

The Pilgrim's Journey

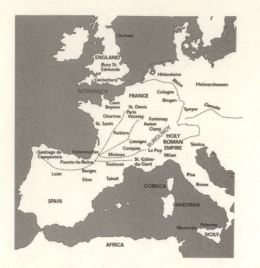

15-6. Reconstruction drawing of the Abbey (Cluny III), Cluny, Burgundy, France. 1088–1130. *(page 478)*

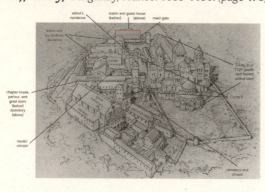

15-7. Plan of the Abbey of Notre-Dame, Fontenay, Burgundy, France. 1139–47. *(page 479)*

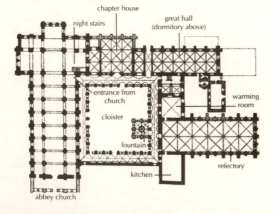

Notes

15-8. Nave, Abbey Church of Notre-Dame, Fontenay. 1139–47. *(page 479)*

15-9. *Doubting Thomas*, pier in the cloister of the Abbey of Santo Domingo de Silos, Castile, Spain. c. 1100. *(page 480)*

15-10. South portal and porch, Priory Church of Saint-Pierre, Moissac, Tarn-et-Garonne, France. c. 1115. *(page 481)*

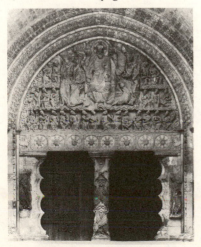

15-11. *Lions and Prophet Jeremiah (?),*
trumeau of the south portal, Priory Church of Saint-
Pierre. Moissac. *(page 482)*

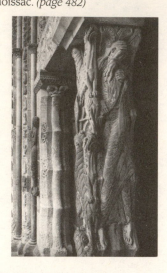

15-12. Gislebertus. *Last Judgment*
**tympanum on west portal, Cathedral
(originally abbey church) of Saint-Lazare,
Autun,** Burgundy, France. c. 1130–45. *(page 483)*

15-13. *Weighing of Souls*, detail of *Last Judgment* tympanum, Cathedral of Saint-Lazare, Autun. *(page 483)*

15-14. Gislebertus. *The Magi Asleep*, capital from the choir, Cathedral of Saint-Lazare. c. 1120–32. *(page 483)*

Elements of Architecture:
The Romanesque Church Portal

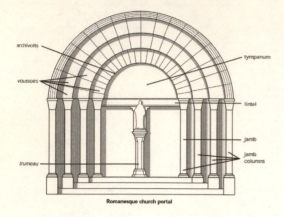

archivolts

voussoirs

tympanum

lintel

jamb

jamb columns

trumeau

Romanesque church portal

INDEPENDENT SCULPTURE

15-15. *Virgin and Child,* from the Auvergne region, France. Late 12th century. *(page 485)*

15-16. *Batlló Crucifix,* from Catalonia, Spain.
Mid-12th century. *(page 486)*

WALL PAINTING

**15-17. Nave, Abbey Church of Saint-
Savin-sur-Gartempe, Poitou,** France. c. 1100.
(page 487)

15-18. *Tower of Babel,* detail of painted nave vaulting, Abbey Church of Saint-Savin-sur-Gartempe, Poitou, France. c. 1100. *(page 488)*

15-19. *Christ in Majesty,* detail of apse painting from the Church of San Clemente, Tahull, Catalonia, Spain. c. 1123. *(page 489)*

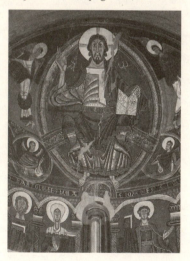

BOOKS

15-20. Page with *Pentecost*, Cluny Lectionary.
Early 12th century. *(page 490)*

15-21. Page with *The Tree of Jesse*,
*Explanatio in Isaiam (Saint Jerome's Commentary on
Isaiah)*, from the Abbey of, Cîteaux, Burgundy,
France. c. 1125. *(page 491)*

THE NORTH SEA KINGDOMS

TIMBER ARCHITECTURE
AND SCULPTURE

15-22. Borgund stave church, Sogn, Norway.
c. 1125–50. *(page 492)*

15-23. Doorway panels, Parish church, Urnes,
Norway. c. 1050–70. *(page 493)*

MASONRY ARCHITECTURE

15-24. Castle-monastery-cathedral complex, Durham, Northumberland, England. c. 1075–1100s, plus later alterations and additions. *(page 494)*

15-25. Plan of Durham Castle. *(page 494)*

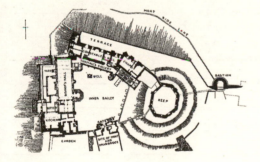

15-26. Nave of Durham Cathedral. Late
11th–early 12th century. *(page 495)*

Elements of Architecture:
Timber Construction

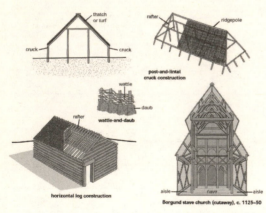

15-27. Church of Saint-Étienne, Caen,
Normandy, France. c. 1060–77. *(page 497)*

15-28. Nave, Church of Saint-Étienne,
Caen. Vaulted c. 1130. *(page 497)*

**15-29. Composite diagram of Church of
Saint-Étienne, Caen,** showing original 11th-
century timber roof and later 12th-century six-part
vault inserted under the roof. *(page 497)*

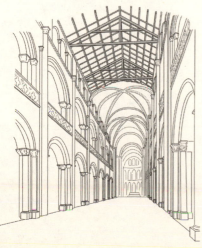

BOOKS

15-30. John of Worcester. Page with *Dream of Henry I*, *Worcester Chronicle*, from Worcester, England. c. 1140. *(page 498)*

15-31. Page with *Hellmouth*, *Winchester Psalter*, from Winchester, England. c. 1150. *(page 499)*

THE BAYEUX TAPESTRY

15-32. *Bishop Odo Blessing the Feast*,
section 47–48 of the *Bayeux Tapestry*, Norman-
Anglo-Saxon embroidery from Canterbury, Kent,
England, or Bayeux, Normandy, France. c. 1066–82.
(page 499)

The Object Speaks:
The Bayeux Tapestry

15-33. *Messengers Signal the Appearance of a Comet (Halley's Comet),* panel 32, section 20 of the *Bayeux Tapestry*, Norman–Anglo-Saxon embroidery from Canterbury, Kent, England, or Bayeux, Normandy, France. c. 1066–82. *(page 500)*

Technique:
Embroidery Techniques

Laid-and-couched work and **stem-stitch techniques** are clearly visible in this detail of figure 15-32. Stem stitching outlines all the solid areas, is used to draw the facial features, and forms the letters of the inscription. *(page 501)*

THE HOLY ROMAN EMPIRE

ARCHITECTURE

15-34. Interior, Speyer Cathedral, Speyer,
Germany, as remodeled c. 1081–1106. *(page 503)*

**15-35. Nave, Church of Sant'Ambrogio,
Milan,** Lombardy, Italy. Church begun 1080;
vaulting after 1117. *(page 503)*

METALWORK

15-36. Tomb cover with effigy of Rudolf of Swabia, from Saxony, Germany. After 1080. *(page 504)*

15-37. Roger of Helmarshausen. Portable altar of Saints Kilian and Liborius, from the Abbey, Helmarshausen, Saxony, Germany. c. 1100, with later additions. *(page 505)*

15-38. Griffin aquamanile, in the style of
Mosan, Liège (?), Belgium. c. 1130. *(page 505)*

BOOKS

**15-39. Facsimile frontispiece with
Hildegard and Volmer,** *Liber Scivias.* 1165–75.
(page 506)

15-40. Page with self-portrait of the nun Guda, *Book of Homilies,* from Germany. Early 12th century. *(page 507)*

ANCIENT ROME
AND ROMANESQUE ITALY

15-41. Cathedral complex, Pisa, Tuscany, Italy. Cathedral begun 1063; baptistry begun 1153; campanile begun 1174; Campo Santo 13th century. *(page 508)*

15-42. Nave, Church of San Clemente, Rome. c. 1120–30. *(page 509)*

15-43. Wiligelmus. *Creation and Fall,* on the west facade, Modena Cathedral, Modena, Emilia, Italy. Building begun 1099; sculpture 1106–20. *(page 510)*

16
GOTHIC ART

Notes

16-1. Triforium wall of the nave, Chartres Cathedral, the Cathedral of Notre-Dame, Chartres, France. c. 1194–1260. *(page 512)*

THE GOTHIC STYLE

Map 16-1. Europe in the Gothic Era. The Gothic style began in the Île-de-France in about 1140 and spread throughout Europe during the next 250 years. *(page 514)*

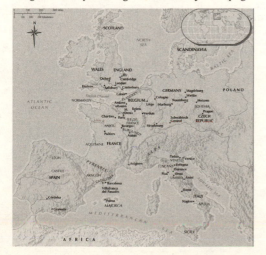

16-2. Chartres Cathedral, the Cathedral of Notre-Dame, Chartres, Eure-et-Loir, France. West facade begun c. 1134; cathedral rebuilt after a fire in 1194 and building continued to 1260; north spire 1507–13. *(page 515)*

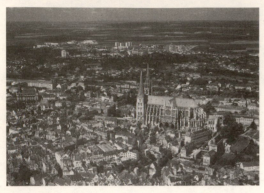

FRANCE

ARCHITECTURE AND ITS DECORATION

Romance

Attack on the Castle of Love, lid of a jewelry box, from Paris. c. 1330–50. *(page 517)*

16-3. West facade, Abbey Church of Saint-Denis, Saint-Denis, France. 1140–44. *(page 518)*

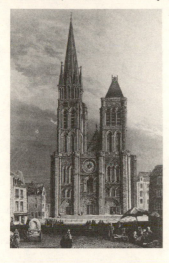

16-4. Ambulatory choir, Abbey Church of Saint-Denis. *(page 519)*

16-5. Plan of the sanctuary, Abbey Church of Saint-Denis. *(page 519)*

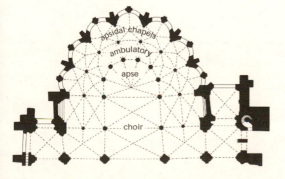

16-6. Ambulatory vaults, Abbey Church of Saint-Denis. *(page 519)*

Elements of Architecture: Rib Vaulting

groins

masonry webbing diagonal ribs

pointed arch

pattern of ribs

groin vault

four-part rib vault

complex rib vault

16-7. West facade, Chartres Cathedral, the Cathedral of Notre-Dame, Chartres, France. c. 1134–1220; south tower c. 1160; north tower c. 1150–75; north spire 1507–13. *(page 521)*

16-8. Royal Portal, west facade, Chartres Cathedral. c. 1145–55. *(page 522)*

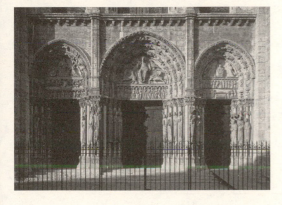

16-9. *Prophets and Ancestors of Christ,* right side, central portal, Royal Portal, Chartres Cathedral. c. 1145–55. *(page 523)*

16-10. *Saint Stephen* (right, c. 1210–20) and *Saint Theodore* (left, c. 1230–35), left side, left portal, south transept entrance, Chartres Cathedral. *(page 523)*

16-11. Flying buttresses, Chartres Cathedral, France. c. 1194–1220. *(page 524)*

16-12. Plan of Chartres Cathedral. c. 1194–1220. *(page 524)*

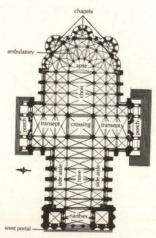

16-13. Nave, Chartres Cathedral. c. 1194–1220.
(page 525)

16-14. *Tree of Jesse*, west facade, Chartres
Cathedral. c. 1150–70. *(page 526)*

16-15. *Charlemagne Window*, ambulatory
apse, Chartres Cathedral. c. 1210–36. *(page 526)*

Elements of Architecture:
The Gothic Church

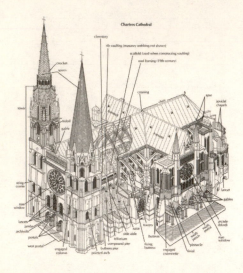

Technique: Stained-Glass
Windows

16-16. *Furrier's Shop,* detail of *Charlemagne Window. (page 528)*

16-17. Vaults, sanctuary, Amiens Cathedral, Cathedral of Notre-Dame, Amiens, Somme, France. Upper choir after 1258; vaulted by 1288. *(page 529)*

16-18. Robert de Luzarches, Thomas de Cormont, and Renaud de Cormont. Plan of Amiens Cathedral. 1220–88. *(page 530)*

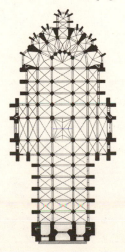

16-19. Nave, Amiens Cathedral. 1220–88;
upper choir reworked after 1258. *(page 530)*

16-20. West facade, Amiens Cathedral. Begun
c. 1220–36 and continued through the 15th century. *(page 531)*

16-21. *Virtues and Vices*, central portal, west entrance,
Amiens Cathedral, France. c. 1220–36. *(page 532)*

16-22. *Beau Dieu,* trumeau, central portal, west facade, Amiens Cathedral, France. c. 1220–36. *(page 532)*

**The Object Speaks:
Notre-Dame of Paris**

16-23. Cathedral of Notre-Dame, Paris.
Begun 1163; choir chapels 1270s; spire 19th-century replacement. *(page 533)*

16-24. West facade, Reims Cathedral, Cathedral of Notre-Dame, Reims, France. Rebuilding begun 1211 to height of rose window by 1260; towers left unfinished in 1311; additional work 1406–28. *(page 534)*

16-25. *Annunciation* (left pair: Mary [right] c. 1245, angel [left] c. 1255) and ***Visitation*** (right pair: Mary [left] and Elizabeth [right] c. 1230), right side, central portal, west facade, Reims Cathedral. *(page 535)*

16-26. *Saint Joseph,* left side, central portal, west facade, Reims Cathedral. c. 1255. *(page 536)*

16-27. Plan of Reims Cathedral. 1211–60. *(page 536)*

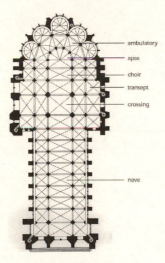

16-28. Nave, Reims Cathedral. Begun at east 1211; nave c. 1220; finished for coronation of 1286. *(page 537)*

16-29. Perre de Montreuil (?), facade and south side, the Sainte-Chapelle, Paris. 1243–48; rose window 1490–95. *(page 538)*

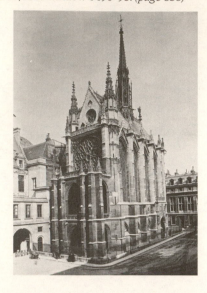

16-30. Interior, upper chapel, the Sainte-Chapelle, Paris. *(page 538)*

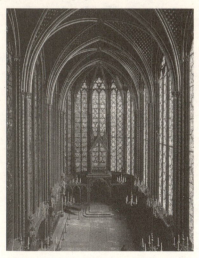

INDEPENDENT SCULPTURE

16-31. *Virgin and Child,* from the Abbey
Church of Saint-Denis, France. c. 1339. *(page 539)*

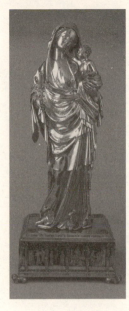

BOOK ARTS

**16-32. Villard de Honnecourt. Sheet of
drawings with geometric figures and
ornaments,** from Paris. 1220–35. *(page 540)*

16-33. **Page with *Louis IX and Queen Blanche of Castile*,** Moralized Bible, from Paris. 1226–34. *(page 540)*

16-34. **Page with *Abraham, Sarah, and the Three Strangers*,** *Psalter of Saint Louis*, from Paris. 1253–70. *(page 541)*

16-35. **Page with *David and Saul*,** *The Morgan Library Picture Bible*, from Paris, c. 1250. *(page 542)*

16-36. Jean Pucelle. Pages with *Betrayal and Arrest of Christ,* folio 15v. (left), and ***Annunciation***, folio 16r. (right), *Book of Hours of Jeanne d'Evreux*, from Paris. c. 1325–28. *(page 543)*

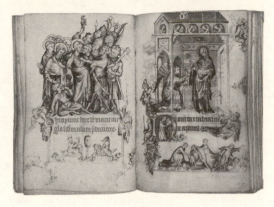

LATER GOTHIC ARCHITECTURE

ENGLAND

ARCHITECTURE

16-37. Salisbury Cathedral, Salisbury, Wiltshire, England. 1220–58; west facade 1265; spire c. 1320–30; cloister and chapter house 1263–84. *(page 545)*

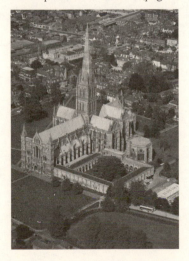

16-38. Plan of Salisbury Cathedral. *(page 545)*

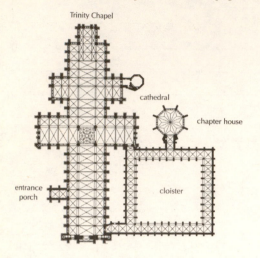

16-39. Nave, Salisbury Cathedral. *(page 545)*

Elements of Architecture: The Gothic Castle

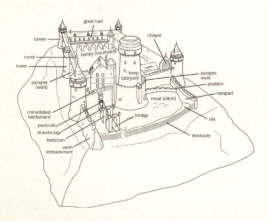

16-40. Sanctuary, Exeter Cathedral, Exeter,
Devon, England. c. 1270–1366. *(page 547)*

Master Builders

Page with ***King Henry III Supervising the Works***,
copy of an illustration from a 13th-century English
manuscript; original in The British Library, London.
(page 547)

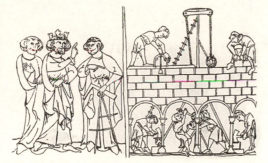

16-41. William Hurley. Lantern Tower, Ely Cathedral, Ely, Cambridgeshire, England. 1328–47. *(page 548)*

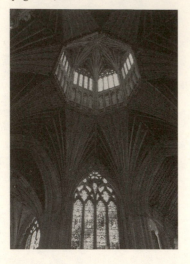

BOOK ARTS

16-42. Page with *Psalm 1 (Beatus Vir)*, *Windmill Psalter*, from London. c. 1270–80. *(page 549)*

OPUS ANGLICANUM

16-43. *Life of the Virgin,* back of the
Chichester-Constable chasuble, from a set of
vestments embroidered in *opus anglicanum*, from
southern England. 1330–50. *(page 550)*

SPAIN

ARCHITECTURE

16-44. Cathedral of Palma, Mallorca,
Balearic Islands, Spain. Begun 1306. *(page 551)*

16-45. Nave and side aisle, Palma Cathedral.
(page 551)

BOOK ARTS

16-46. Page with *Alfonso the Wise*,
Cantigas de Santa María, from Castile, Spain.
c. 1280. *(page 551)*

PAINTED ALTARPIECES

16-47. Luis Borrassá. *Virgin and Saint George*, altarpiece in Church of San Francisco, Villafranca del Panadés, Barcelona. c. 1399. *(page 552)*

16-48. Luis Borrassá. *Education of the Virgin*, detail from *Virgin and Saint George* altarpiece. Church of St. Francisco, Villafranca del Paradés (Barelona), Spain. 14th Century. *(page 553)*

GERMANY AND THE HOLY ROMAN EMPIRE

ARCHITECTURE

16-49. Peter Parler. Choir, Church of the Holy Cross, Schwäbisch Gmünd, Germany. Begun 1351; vaulting completed 16th century. *(page 553)*

16-50. Plan of Church of the Holy Cross, Schwäbisch Gmünd. *(page 554)*

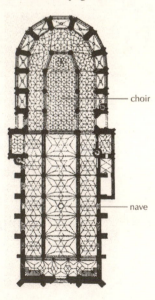

16-51. Interior, Altneuschul, Prague,
Bohemia (Czech Republic). c. late 13th century;
bimah after 1483; later additions and alterations.
(page 554)

16-52. Plan of Altneuschul. *(page 554)*

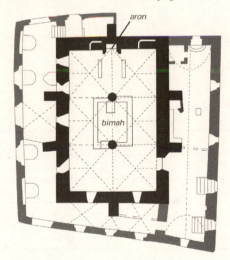

SCULPTURE

16-53. Nicholas of Verdun and workshop.
Shrine of the Three Kings. c. 1190–c. 1205/10.
(page 555)

16-54. *Dormition of the Virgin,* south
transept portal tympanum, Strasbourg Cathedral,
Strasbourg, France. c. 1230. *(page 556)*

16-55. *Saint Maurice* Magdeburg Cathedral, Magdeburg, Germany. c. 1240–50. *(page 556)*

16-56. *Ekkehard and Uta,* west chapel sanctuary, Naumburg Cathedral, Naumburg, Germany. c. 1245–60. *(page 551)*

16-57. *Vesperbild,* from Middle Rhine region, Germany. c. 1330. *(page 558)*

ITALY

ARCHITECTURE

16-58. Arnolfo di Cambio, Francesco Talenti, Andrea Orcagna, and others. Florence Cathedral, Florence. Begun 1296; redesigned 1357 and 1366; drum and dome by Brunelleschi, 1420–36; campanile by Giotto, Andrea Pisano, and Francesco Talenti, c. 1334–50. *(page 559)*

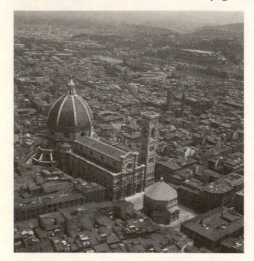

16-59. Plan of Florence Cathedral. 1357–78. *(page 559)*

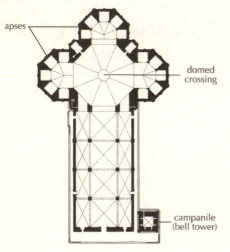

apses

domed crossing

campanile (bell tower)

16-60. Facade, Siena Cathedral, Siena.
Lower half of facade, including statuary, 1284–99.
(page 560)

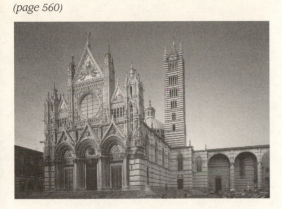

SCULPTURE

**16-61. Nicola Pisano. Pulpit, Baptistry,
Pisa.** 1260. *(page 560)*

The Black Death

Master of the Triumph of Death. *The Three Living Meet the Three Dead*, **detail of lower left corner of** *The Triumph of Death,* fresco on a wall in the Campo Santo, Pisa. 1330s. *(page 561)*

16-62. Nicola Pisano. *Nativity,* detail of pulpit, Baptistry, Pisa, Italy. 1260. *(page 562)*

16-63. Giovanni Pisano. *Nativity,* detail of pulpit, Pisa Cathedral, Pisa. 1302–10. *(page 562)*

16-64. Andrea Pisano. *Life of John the Baptist,* south doors, Baptistry of San Giovanni, Florence. 1330–36. *(page 563)*

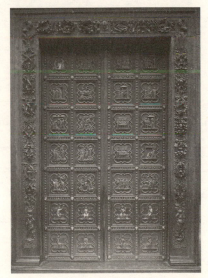

PAINTING

Church Furniture

Saint Francis Master. *Miracle of the Crib at Greccio*, fresco in upper church of San Francesco, Assisi, Italy. c. 1295–1301/30. *(page 564)*

16-65. Coppo di Marcovaldo. *Crucifix,* from Tuscany, Italy. c. 1250–1270. *(page 565)*

16-66. Duccio di Buoninsegna. *Virgin and Child in Majesty,* main panel of *Maestà Altarpiece,* from Siena Cathedral. 1308–11. *(page 565)*

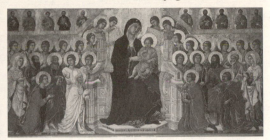

16-67. Plan of front and back of *Maestà Altarpiece.* *(page 566)*

 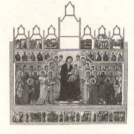

16-68. Simone Martini and Lippo Memmi. *Annunciation and Saints,* altarpiece from Siena Cathedral. 1333. *(page 567)*

16-69. Pietro Lorenzetti. *Birth of the Virgin,*
from Siena Cathedral. c. 1335–42. *(page 568)*

Technique: Buon Fresco

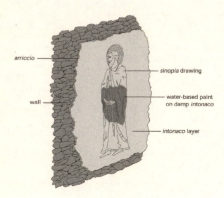

arriccio

sinopia drawing

wall

water-based paint
on damp *intonaco*

intonaco layer

16-70. Ambrogio Lorenzetti. *Allegory of Good Government in the City* and *Allegory of Good Government in the Country,* frescoes in the Sala della Pace, Palazzo Pubblico, Siena, Italy. 1338–40. *(page 570)*

16-71. Cimabue. *Virgin and Child Enthroned,* painted for the high altar of the Church of Santa Trinità, Florence. c. 1280. *(page 572)*

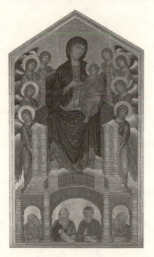

16-72. Giotto di Bondone. *Virgin and Child Enthroned,* painted for the high altar of the Church of the Ognissanti (All Saints) c. 1305–10. *(page 573)*

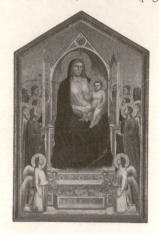

16-73. Giotto di Bondone. *Last Judgment* on west wall, *Life of Christ and the Virgin* on north and south walls, Arena (Scrovegni) Chapel, Padua. Consecrated 1305. *(page 574)*

16-74. Giotto di Bondone. *The Lamentation.* 1305–1306. *(page 575)*

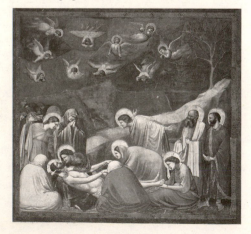